Simply
Mosaics

Over 30 easy projects for your home and garden

Simply
Mosaics

Over 30 easy projects for
your home and garden

Tracy Boomer &
Deborah Morbin

D&C
David and Charles

www.rucraft.co.uk

DEDICATION

This book is dedicated to Wilsia Metz, who has always believed in us.

ACKNOWLEDGEMENTS

We're not going to say anything about last-minute acknowledgements (and how we are going to try and be more organised) because after six books we still haven't got it right when it comes to doing them well in advance. So it's time to admit that it will never happen. As a result of this tardiness on our part, please forgive us if we forget to mention you.

We know this sounds weird, but we would like to thank each other because when one of us fades or comes up against a creative block, the other immediately picks up the slack.

Now that we've got that over and done with, we'd like to thank our friend and publisher, Wilsia, for giving us a little extra breathing space when life interfered with our plans, even though it meant her schedule became a lot tighter. The same goes for Lindie Metz, our wonderful designer who also stepped in and took on the role of general gopher. Then of course, there's the other Metz, Ralf, who provided food and gin and tonics at the end of a long day. He even learned how to cook vegetables for the 'ridiculous vegetarian'.

Then there's Ivan Naude, our favourite photographer – your patience, creativity and humour make photo shoots fun.

Of course, we have to mention Mr Nit-picker, Christopher: thank you for editing two-thirds of the manuscript at the 11th hour when we used our female wiles to make you feel guilty. We did the last third ourselves, so if there are any problems, you can call Christopher and tell him that he needs to get his act together next time.

Thanks to our kids who helped out: Natasha and Alexander for projects and James for cutting tiles for us.

We'd also like to thank Ruth and Craig Renwick of The Knysna Pottery House for making both ceramic tiles and embellishments to our specifications – and giving us inspiration and ideas. We also got great ideas and advice from Marylou Newdigate.

Thank you to Monica de Beer from Eben Farm for opening up her beautiful house to us (and supplying us with coffee and the most delicious biscuits) for the photo shoot.

Thanks also to thank Jacqui Charles of Mosaic Works for her support and for going out of her way to help when we had a last-minute query during our photoshoot.

A last-minute, but big thank you to our translator, Annlerie van Rooyen, who was brilliant at picking up on typos and oversights.

Lastly, we'd like to thank you crafters who have supported us over the past ten years. We really would never have got past the first book if it wasn't for you.

A DAVID & CHARLES BOOK
© Metz Press 2011

Text © Deborah Morbin & Tracy Boomer
Photographs © Metz Press 2011

Originally published as *Mosaics*
by Metz Press in 2011

First published in the UK and USA in
2011 by F&W Media International, LTD

David & Charles is an imprint of
F&W Media International, LTD
Brunel House, Forde Close, Newton
Abbot, TQ12 4PU, UK

F&W Media International, LTD is a
subsidiary of F+W Media Inc.
4700 East Galbraith Road, Cincinnati,
OH 45236, USA

ISBN-13: 978-1-4463-0159-3 paperback
ISBN-10: 1-4463-0159-1 paperback

Printed in China by WKT Co Ltd
for F&W Media International, LTD

contents

■■■■■■■■■■■■■■■■■■■

introduction 6

getting started 8

techniques 23

projects 30

■■■ ideas for the living room 31

■■■ ideas for the dining room 52

■■■ ideas for the kitchen 67

■■■ ideas for the bathroom 85

■■■ ideas for work & play 96

■■■ ideas for outdoors 121

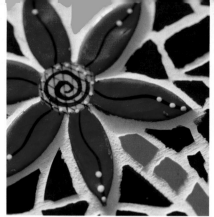

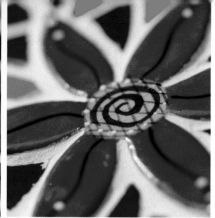

introduction

We first started playing around with mosaics about seven years ago when we were working on our general craft book, *Stylish Crafts for your home*. Mosaic was becoming quite popular at the time but a lot of the books you could buy were fairly intimidating for beginners, so we stuck to basic techniques that were easy to follow. Several years later, mosaic is more popular than ever, so we decided (with more than a little prompting from our publisher) that we would dedicate an entire book to the craft. As a result of its popularity, there is a wide range of materials and embellishments available today that simply weren't around when we first started. The decorative embellishments in particular not only make mosaicing easier – because you don't have to do any intricate tile cutting – but also give the craft a different look. In fact, if you have done any scrap-booking over the past couple of years, you will more than likely get a feeling of *déjà vu* when you take a look at the embellishments available for mosaicing.

Speaking to people who are interested in mosaic work, and also to retailers, it seems that what hasn't changed though is the fact that the average person taking up the craft does not want to get too involved in intricate cutting. In fact, they would be quite happy to do no cutting at all! They want to keep it simple and, in this vein, prefer to stick to the **direct method** of application because it is normally the most straightforward one. As a result, all of our projects have been done in this way.

We don't profess to be experts in this field: mosaic work can be a beautiful, intricate art form that takes months to complete and there are some fantastic mosaic artists out there. However, having said that, after writing six craft books, we do have a good idea of what the average crafter wants. And that is **not** getting involved in a craft that takes so long to complete! There are very few of us that have that kind of time (or patience). We've also noticed that most people want to make practical items for their homes, rather than a 'mosaic painting' to hang on the wall.

Like everyone else (except our husbands – who think they are perfect), we also make mistakes. And, as we have done in our previous books, we use these mistakes to guide you in the form of our instructions and handy hints. That way you can avoid making the same ones we did. We hope that you will find the book inspirational and easy-to-follow and that it leads to many happy hours of mosaicing.

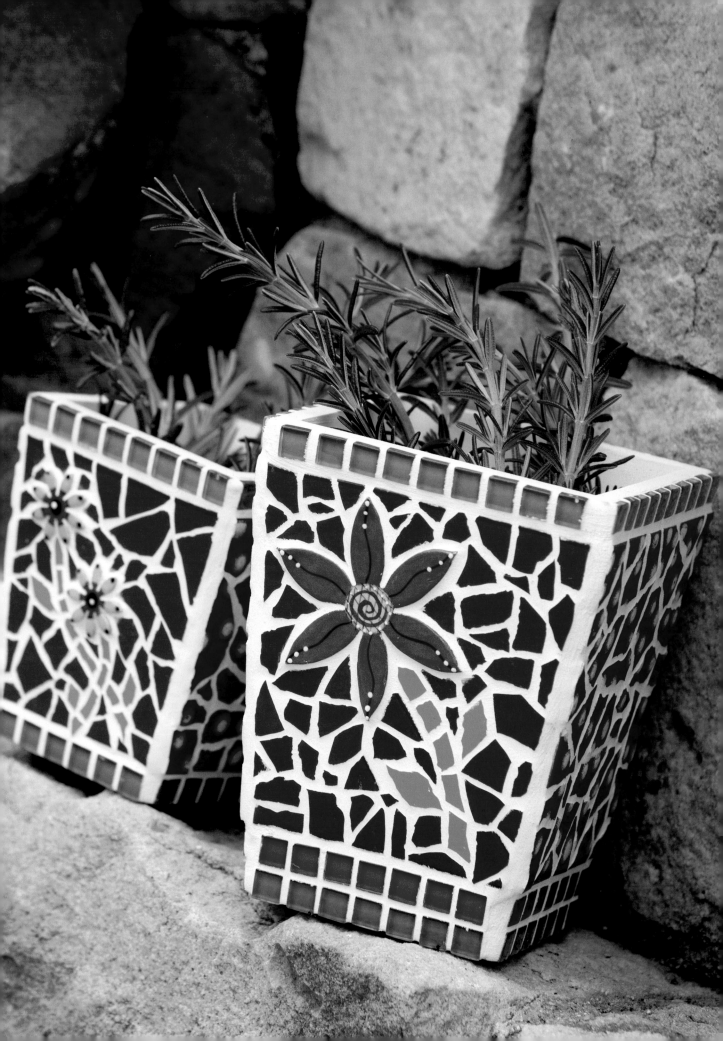

getting started

■ ■ ■ ■ ■ ■ ■ ■ ■ ■ ■ ■ ■ ■ ■ ■

This chapter covers what you will need to get going. You don't have to rush out and buy everything mentioned at once – rather buy the items as you need them. Those of you who have been crafters for a while will be well aware of the fact that you can easily get carried away in your enthusiasm to start a new craft and end up spending a small fortune on stuff that you may never get around to using. We are masters when it comes to this, so don't fall into the same trap. This is particularly important when you are faced with all the decorative embellishments currently available. They can be pretty hard to resist, but bear in mind that, as enticing as they are, they are not particularly cheap. So rather buy them with a specific project in mind instead of thinking: "This is so pretty, I'll definitely use it sometime …"

If you want to build up a little stash, rather spend the money on plain tiles, especially colours that you're bound to use regularly, like black and white. If you have done scrapbooking, then you can relate this tip to buying more plain cardstock than patterned paper because you are much more likely to use the former.

As far as the other equipment is concerned, obviously the first thing you will need is something to mosaic – your base material – and here your options really are endless. You can give an old piece of furniture a 'face-lift'; or use new, raw superwood blanks (often associated with decoupage) or turn glass tumblers into attractive candleholders, to name but a few. In fact, we both ended up 'redecorating' some of the decoupaged items from our previous books.

Then there are the hand-held cutters. Even if you are pretty adamant that you do not want to cut at all, at least give it a chance … you may be surprised at the results. The various cutting tools are relatively inexpensive so you can afford to experiment.

Of course, you'll need something to stick the tiles down with and then there's the grout. If you are new to this, it may be starting to sound a bit daunting. Don't worry, it really shouldn't be. We'll cover all of this in easy-to-understand detail in this section.

TILES 'N STUFF

You will often see these referred to in other books as *tesserae* but, as we don't speak Latin, we prefer *tiles 'n stuff*. These can be glass tiles, mirror tiles, ceramic tiles, pebbles, shells, coins, medallions etc. We also find that it's a lot easier to go into a hardware or craft store and ask to see their range of tiles for mosaic work. If you're feeling particularly frisky one morning, you can try asking them where they keep their *tesserae* but there's a 99% chance that your request will be met with that blank, "Uh?", look.

As mentioned above, tiles aren't the only materials that you can use in your work. You could also use broken china, pebbles, semi-precious stones, shells, jewellery or *millefiori* (handmade glass beads with colourful patterns on them). In fact, mosaic work has changed so much over the past year or so that your choices are endless. We've even heard of someone who stuck her daughter's old Barbie doll in one of her mosaic items. If it sticks and you can grout around it, then use it!

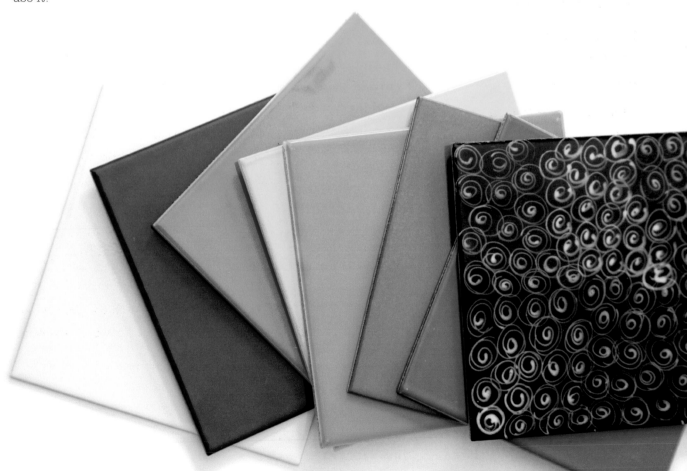

Glass tiles

There are specific names for the various glass tiles but again the average crafter doesn't need to know this because it could just end up being confusing if you aren't familiar with the terms. We've also noticed that different countries (and companies, for that matter) also have different names for them. So, we prefer to keep things simple: glass tiles are the ones that are, um, clear glass with the colour coming through from the base of the tile. They come in a multitude of colours and are normally pressed into sheets. They can be fairly expensive, depending on colour, 'glitz' and size. The size usually varies between approximately 1 cm x 1 cm and 2.5 cm x 2.5 cm but occasionally you will get slightly larger ones (4 cm x 4 cm) though we seldom use those.

They are fairly easy to cut but you have to take care when doing so, because tiny glass shards are produced in the process. **Do not** use your hands to gather these pieces together as they have a way of ending up embedded in your palms! In fact, one of us (who shall remain nameless but is the same person who always covers herself in paint or glue, depending on the project) has so far found about a dozen ways in which to make herself bleed when mosaicing. Which is bad for her, but good for you because we can pass on the warnings. In this case, clean up the glass shards with a tissue, which you can throw away. Alternatively, if you've done a fair amount of cutting and the glass splinters are spread over a bigger area, use a soft brush and dustpan. Be sure to also sweep the floor underneath and around the table you have been working on. Sometimes the shards can shoot fairly far and it's no fun getting them in your feet (oh yes, that has happened too!) If the idea of cutting glass still worries you, there is actually a sure-fire way of avoiding having pieces of glass shoot all over your workroom: half fill a bowl or bucket with water and cut the tile **under** the water.

Vitreous glass tiles

Yes, I know we said we weren't going to get technical with tile names but there was no way around this one, simply because while these tiles are made of glass they fall into a slightly different category. In this case, the colour doesn't just come from the base – the entire tile is coloured. If the shop assistant looks blank when you ask for them, say: "The ones commonly used around a swimming pool that are normally textured underneath." These tiles are easy to cut and don't tend to produce as many shards as the ones mentioned above. However,

they **are** glass, so take the same precautions. Vitreous glass tiles are also cheaper than the plain glass ones – again though, prices will also fluctuate according to colour and glitz. They tend to only come in one size: 2 cm x 2 cm.

Mirror tiles

This is also a type of glass so all of the above advice holds true. Mirror tiles are not as easy to cut as the glass tiles, but that doesn't mean that it can't be done … it just takes a little more practice. If you aren't keen on cutting the glass yourself, you can often find a tile merchant who will do it for you, especially if they stock mosaic materials, which a lot of them are doing these days. You may even find that they sell small bags of ready-cut mirror tiles – various sized squares, rectangles and also mixed shapes, so you really don't have to do any cutting if you'd rather avoid it.

Glazed ceramic tiles

In our opinion, these should make up the bulk of your 'stash' and range in size from about 10 cm x 10 cm to 15 cm x 15 cm. There is a range available specifically for mosaic work, which is really easy to cut, so if this is going to be your first attempt at a project that needs cutting, we suggest you start with these tiles. The tiles can be bought individually, which means you only have to buy what you need. As mentioned before though, stock up on the basic colours, like black and white (and some of your own personal favourites) if you intend taking this up as an ongoing hobby or business.

When purchasing the tiles, hold each one up to the light to ensure that the glazed surface is smooth and there aren't any fine cracks in it. We've come across flawed tiles before and they are extremely frustrating to use: the defective, 'crackled' surface causes them to chip when you cut them.

Bear in mind that these soft tiles will not stand up to the elements because they have only been low-fired. The sturdier, high-fired floor tiles **are** suitable for outdoor use but are a lot more difficult to cut.

Unglazed ceramic tiles

These tiles normally come in fairly soft, earthy colours and there is no 'right or wrong' side. They are matt, frost-proof and hard wearing so can be used confidently on the floor in high-traffic areas or outdoors, which most of the other tiles mentioned here cannot. If you want to do a mosaic on the floor but find these tiles too muted, you **can** use glazed ceramic tiles, but then ensure that you are using the thicker ones (more difficult to cut) that are suitable for floors.

You can normally buy sheets of these tiles or mixed bags of individual, randomly coloured ones. They are normally about 2 cm x 2 cm in size, though you do occasionally get them bigger.

Millefiori

These handmade glass beads come in a variety of different colours and have either geometric or flowery designs on them. Unfortunately they are pretty expensive so use them sparingly; luckily they make more of an impact that way anyhow! They are often sorted according to designs or colours and sold in small packs.

Pebbles

Here we are talking about the glass variety that are available from craft, tile or some décor shops; or natural stone pebbles that you have collected (or bought from the above-mentioned places). Obviously, the pebbles are easier to stick down if they have one 'flattish' side, so explain this to your kids while you lie on the beach with a good book and they go hunting for the perfect pebbles, explaining to them that they should really take their time …

Broken china

Now is a good time to accidentally drop the hideous platter that your mother-in-law bought for you; you know, the one that you always have to dig out from the back of the cupboard when she's coming to visit. Because, strangely enough, some of the ugliest china used in a mosaic together with plain tiles can actually look rather fetching. Of course you should make sure that the item you break isn't some family heirloom that's about a hundred years old and is worth a small fortune.

If you don't have anything at home worth smashing, pay a visit to junk shops or even inexpensive homeware shops that sell crockery items individually. Plates or platters are preferable to cups and bowls because the curves of the latter can be difficult to work with, unless you are using really small pieces.

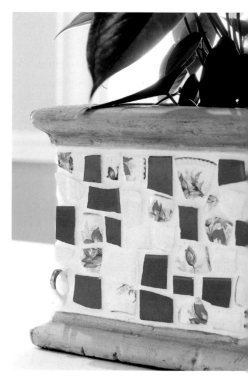

Handmade or stained glass

We haven't used any stained glass in this book (because we couldn't find any) but decided to include it in this section anyway as people often ask about it, so we thought we'd investigate. It is thinner than the tiles normally used in mosaic but comes in beautiful colours that can be cut using a glass cutter.

We worked with handmade glass, which didn't involve any cutting. If you aren't sure where to find someone to make the pieces for you, visit local craft markets where you will often find crafters who work with handmade glass – they are usually more than happy to help you out.

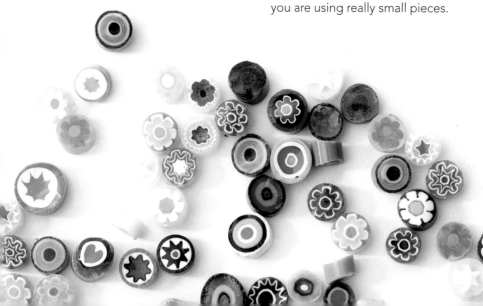

Glazed ceramic embellishments

A few years ago, if you wanted to make a box with a rose or a chilli on it, you had to actually put together the image yourself using tile pieces. Not so anymore. Of course you **can** still do that and mosaic purists wouldn't have it any other way, but there's nothing pure about us so we welcome any help that we can get!

Seriously, not only does it make your life easier, it also adds dimension to your work. As we said earlier, it's a little like scrapbooking with all these wonderful embellishments, which brings us back to our motto – 'Less is more'. It is very easy to get carried away when faced with all the pretty embellishments but bear in mind that the more you use, the less their impact. Now and again it's nice to go just a little over-the-top but normally it's better (and cheaper) to keep it simple.

Found objects

This can include virtually anything: shells, beads, jewellery or crystals, to name but a few. If you're making a tray, or place mats, you would obviously have to use something that is uniform because you don't want your crockery wobbling or falling over, in which case these items are not ideal, except as borders or corner decorations. However, when incorporated into a picture frame or on a box, they can become a work of art. The only limit you have is your imagination.

TOOLS

This is where the similarities to scrapbooking end. There are not that many tools needed and, happily, the ones that you **do** need are relatively inexpensive. No cute little hammers, punches, stitching machines etc here. This is something to keep in mind when your husband (wife?) starts complaining about you taking up a new hobby. Explain that the tools required are basic and dirt cheap, compared to what you would need for some other hobbies. Just make sure you don't tell him how much the tiles cost. There is absolutely no reason why he needs to know anyway.

Back to the tools though … you don't need that many and they really are pretty cheap. You may even find that you have a few of them lying around in the garage already.

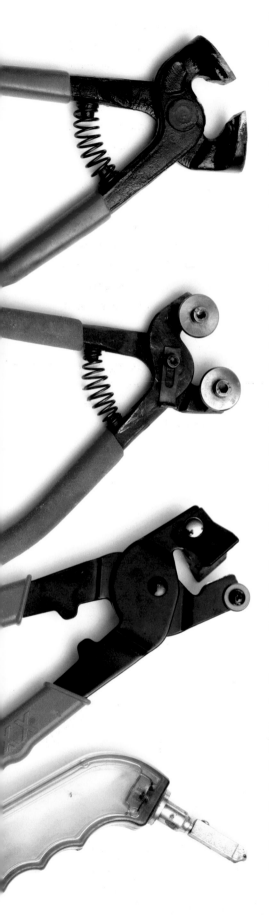

Tile nippers

There are a couple of types of tile nippers and we suggest that you buy both. The reason being that, although you are bound to prefer one of them, they each have their place. We have the same nippers and even though we use both pairs, we each have a preference for one type (and it's not the same one).

SIDE BITERS are the hardier – and more basic – of the two. Both sides of the square 'biting' edge can be used for cutting and they are good for getting through fairly tough material.

WHEELED NIPPERS are definitely better for glass and supposedly better for precise cutting. However, as mentioned, one of us can cut just as precisely with the side biters and only uses the wheeled nippers for cutting glass. Turn the wheels of the nippers as the nipping edge becomes blunt, so that you only need to replace the wheels once the edges are entirely blunt.

Glass cutters

There are a few options here and we have listed the two most popular; but as mentioned above, the wheeled nippers are also good with glass. However, if you want a straight, more controlled cut, you need to use one of these (and bear in mind that they work very well on most other tiles too).

SCORE-AND-SNAP CUTTERS are the cheapest available. In fact, when we first bought one, we were convinced that it wouldn't work very well because it was so cheap – basically the price of two cappuccinos and half a scone. So we were pleasantly surprised (shocked actually) that it was so effective. It can be used on virtually all tiles, not just glass ones.

A GLASS SCORER has a hollow handle, filled with oil, and is used together with a score-and-snapper (it should be running pliers but we couldn't find a pair anywhere!). The oil seeps out when you score the tile, ensuring an easy, clean break once you use the snapper. It's more expensive than the score-and-snap cutters but if you're going to be doing a lot of mosaic work, we recommend getting this one – it'll make your life a lot easier.

Trowels, palette knives … and your favourite butter knife

When it comes to applying adhesive, there are no hard and fast rules here – or maybe there are but we just don't follow them. We have used kitchen knives, toothpicks, palette knives, ice cream sticks and spare bits of tile. If it works for you, then use it!

TROWELS are used to evenly apply adhesive directly onto a fairly large base. The flat edge is used to apply the adhesive and the notched

edge is then drawn across the adhesive, creating ridges. These ridges ensure that the tiles adhere better. We haven't used this method in this book as it normally applies to indirect mosaic. This method is also used for traditional tiling.

PALETTE KNIVES are good for buttering the backs of tile pieces. You can quite easily use a normal butter knife for this though (and no, we do not suggest using the family silver because the knife you use will probably never be the same again).

GROUTING SQUEEGEES come in a variety of sizes and price ranges. Once again, you will end up having a personal preference, so don't spend too much on one unless you really can't work with anything else! They normally have a plastic or wooden handle, with an applicator made of rubber. They work pretty well over most tiles but we have noticed that the rubber starts getting a bit 'tatty' when used on cut glass – the sharp edges of the glass pieces damage the rubber.

OLD CREDIT CARDS make perfect applicators and we tend to use ours all the time. They're easy to handle and seem to have just the right amount of flexibility.

TOOTHPICKS have got to be our best friends. We ensure that we always have them because they are great for applying little amounts of adhesive to small tile pieces. They are also great for cleaning away any excess adhesive that squeezes up around the piece once it has been pressed down.

Miscellaneous

These are the extras that make things easier. You may not need all of them, so go through the list and decide for yourself. Actually, the only things that aren't **really** optional are the sponge and the pencil. As far as the rest is concerned, it's up to you.

TWEEZERS are very handy when it comes to working with small decorations or pieces of tile as they are used to put the item in place.

CRAFT KNIFE. This is not that necessary but if you have a decoupage history you will probably be very fond of your knife and will find all sorts of uses for it. Tracy uses it to separate tiles on a sheet and cuts them into smaller section, as well as to clean away excess adhesive from (and around) glued tiles.

She has also been known to use the tip to apply small amounts of adhesive but then she does seem to have a never-ending supply of blades, so we wouldn't recommend this, as toothpicks are a lot cheaper than replacement blades!

SCISSORS are useful for cutting sheets of tiles into smaller sections. They are also used to cut out patterns so that you can trace around them. If you're a craft knife lover though, you will probably have no need for a pair of scissors.

LARGE PAINTBRUSH or **DECORATOR'S BRUSH** for brushing away tile and glass fragments, both while you are working and when you are finished.

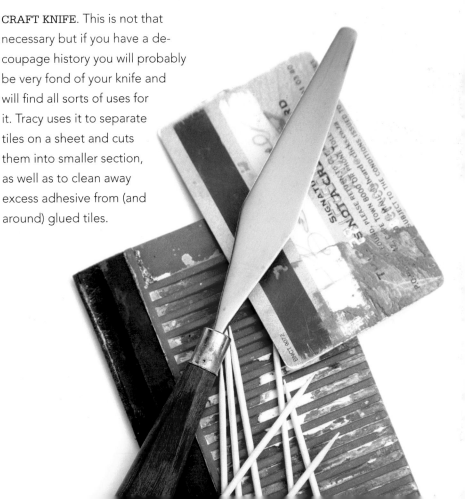

Choose a soft-bristled brush; it will be more effective when it comes to catching the really small shards.

METAL RULER. This is used together with a glass scorer to ensure straight lines for cutting tiles, particularly glass ones. Try to get a corked-backed ruler, which prevents the tile from being scratched while you are working on it.

TILE STONE (or sharpening stone). After Tracy had cut herself yet again on a sharp tile edge, a friend who is a bit of a handyman, suggested that she buy herself one of these to try and prevent more unnecessary bloodshed. Though it is often called a sharpening stone – because it is great for sharpening knives – it actually has the opposite effect on the sharp edges of tiles.

WET AND DRY SANDPAPER. Used wet, this also takes away the sharp edges of tiles. Used dry, it smoothes the rough or 'fuzzy' wood once you have applied the first coat of paint.

PENCILS are used to draw designs directly onto the base and can be used to mark the tiles for cutting. The softer the pencil, the easier it is to use on wood, however, if you find that you can't quite see the markings drawn on the tile, you can try using a felt-tip pen or, better still, get hold of a china marker.

SPONGES are used to clean the grout from the tiles once it's semi-dry. They should be firm and dense to ensure that they slide over the tiles, removing only the excess grout. You will normally find suitable sponges at a hardware store alongside the tiling materials, like applicators and grout.

ACRYLIC CRAFT PAINT. Most of the items you work on will need some kind of painting to finish the project off and give it a professional look. Small bottles of acrylic paint are perfect for this, however, if you are going to be using quite a lot of one particular colour, then rather buy a litre of it from a hardware store as it's a lot more cost-effective this way.

FOAM APPLICATORS or small, flat paintbrushes are perfect for applying the acrylic paint. Remember to wash them properly in soapy water to prevent them from drying out. In between coats you can wrap them in plastic so that you don't need to wash them as frequently.

Large piece of **THICK CARDBOARD** or hardboard to protect the surface on which you are working. You can lay newspapers down as well for added protection.

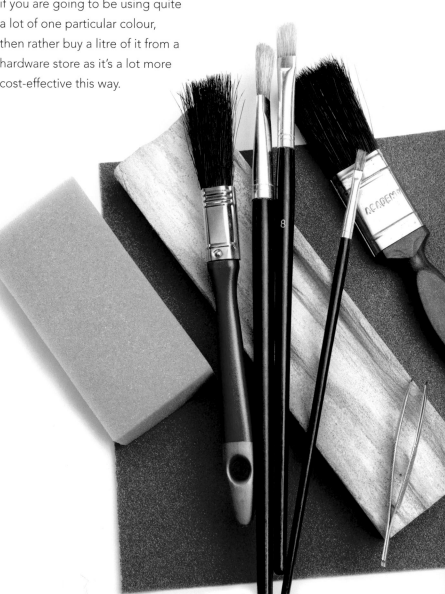

ADHESIVES AND GROUT

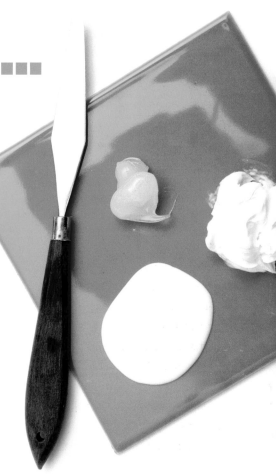

There are a few things that need to be taken into account when deciding which adhesive or grout to use. The first question that you should ask yourself is, "Where is this mosaic going to go?" If it's going to be outdoors, or in a bathroom, you need to take certain steps to ensure that it can stand up to the elements and moisture. (Of course, this also applies to the base that you choose, which will be covered in the next section.)

You also need to bear in mind the amount of 'handling' the item is going to get because then steps can be taken to ensure that the grout can be cleaned easily. A salt and pepper set would obviously be handled a lot more than a picture that hangs on the wall.

Adhesives

As well as taking into account where the item is going to go and how much it is going to be touched, you also need to pay attention to the base on which you are working. Most of the time, you will probably be working on wood so a flexible tile adhesive is perfect for the job. However, it is not recommended for working on glass – for that you need something transparent; and is not really suitable when working with mirror either – you should use something acid free so that it doesn't eventually 'de-silver' the mirror. You can also use specific mosaic grout as both an adhesive and grout, embedding the tiles or other objects into the grout, though this is a little tricky. However, once you have mastered the basics and are eager

to try something new, have a go at it. We haven't covered this specific technique because we are trying to stick to basics, but if you want to experiment, follow the manufacturer's instructions on the back of the packet.

FLEXIBLE TILE ADHESIVE is ready-mixed in a tub and is a must for anyone who is taking up mosaicing. There are two types though: the one is more granular than the other, which is smooth and looks a bit like melted plastic. We prefer the latter because it seems to stick better and doesn't dry too quickly, giving you time to move or slide tiles around if necessary. We find that it's normally easier to buy this adhesive at a tile shop (rather than a hardware store) because

they are more inclined to understand what you are talking about than Average Joe, the Hardware Assistant, who has to know a little bit about a lot of things (but sometimes thinks he knows a lot about everything and you end up with the wrong product!). This adhesive works well on most surfaces. However, if you are working on a project where the adhesive will be visible from underneath the tile – like a glass vase – you need something transparent. And if you don't want to risk your mirror de-silvering over time, you would be better off using silicone.

CLEAR SILICONE ADHESIVE comes in tubes and can be bought at most hardware stores. Look for the one that either says 'mirror' on it, or is described as being 'neutral curing'. This means that there is no acid to corrode the silver of your mirror. It is also perfect to use on the glass vase we just mentioned because it dries clear.

WHITE, WATERPROOF PVA/WOOD GLUE (quickset). We have to admit that we don't use this much anymore, preferring to stick – no pun intended – with the tile adhesive. However, we have used it on some of our earlier projects and it's a great way of introducing your children to mosaic work, because it's a lot easier to clean up! It also dries clear, so you could use it on glass objects.

Grout

Grout is made up of cement and sand and is available in a wide range of colours. If you can't find the colour that you want, you can make it yourself by adding powdered or acrylic craft paint to white grout. If you do this, ensure that you mix enough grout to complete your project because the chances of getting the exact same colour again are fairly slim.

NARROW OR WIDE JOINTS? Be clear about what you are grouting because you get two kinds: cement mixed with fine sand is used in most mosaic projects because the joints are normally narrow. However, if you are going to attempt a large project, with wide joints, you will need a coarser grout. Most of the packets have the width measurements on them, so it shouldn't be too difficult to ensure that you are getting the right one. The grout that is currently being sold in small, clear packets specifically for mosaic are the ones you would use for narrow joints. These packs are great if you are just going to be doing the odd project but if you see yourself doing mosaic work regularly, it's more cost-effective to buy bigger packs of grout like the 1 kg or even 5 kg packs.

MOSAIC TILE ADHESIVE. No, we have not lost the plot: this is a combination of adhesive and grout that you mix yourself. You would normally use it in the indirect method but it can also be used as straightforward grout. It's a little more granular than the grout you would normally use and it's a teeny-weeny bit more difficult to work with because of the adhesive addition but it's also less likely to crack if you have largish joints.

WATERPROOFING SEALANT is used when the finished project is going to be exposed to moisture or handled a lot (it's easier to clean). In that case, you replace the water with waterproofing sealant when mixing the grout.

It's a little more difficult to work with but is worth the effort. This sealant should also be painted over wood (front, back and edges) before beginning to work on it in order to keep it waterproof.

ON A PERSONAL NOTE: Though we mention that you can mix virtually any colour grout, we don't tend to use vibrantly coloured grout, preferring to stick to black, white, grey and the naturals. This probably has something to do with our less-is-more approach to most crafts. Brightly coloured grout can often lead to the finished item looking like, well, something you made yourself. It seems to give the work a childlike look. However, if you love bright colours, then experiment – you may just love it! And if you don't, you can always remove the grout before it dries.

BASE MATERIALS

This really brings back memories of decoupage. One of our husbands said that he had to keep moving otherwise he'd be decorated and covered in eight layers of varnish because we were furiously decoupaging virtually everything in sight! There are a few more limitations when it comes to mosaic, but not many. In fact, when looking around for things to stick tiles on, we both ended up giving some of our old decoupage items a facelift. So, those of you who have our other books would be right if you have a nagging feeling that you'd seen some of these items in some form or another before.

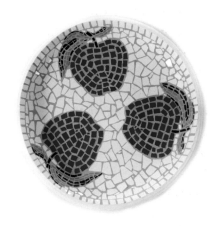

Wood

This is probably the most readily available source of base material, particularly **SUPERWOOD** or **MDF**. There are numerous superwood 'blanks' available from well-equipped craft stores or markets. We've said in the past that this wood is relatively unaffected by humidity, which means it will not shrink or swell over time. However, in its raw state it is not awfully fond of water – a little drop here and there is fine, but if the item you are making is going into a bathroom, it's a good idea to seal it with waterproofing sealant. Something else that we have noticed about this wood is that, if you live at the coast or in an area that is prone to damp, unsealed or undecorated sections are prone to collecting lovely green mould, even if the item isn't in the bathroom. This is not exactly what you want growing on the back of your masterpiece so we suggest that you always seal the back, even if it's only with a couple of coats of paint. Once you've applied the first coat, the wood normally feels a bit rough to the touch. This is because the water-based paint has lifted the fibres slightly, so you need to give it a light sanding before applying subsequent coats of paint. However, you don't have to sand between every coat.

You may want to decorate an item made of **OLD WOOD** that is covered in paint or varnish. In that case, simply sand it using medium-grade sandpaper before you begin working on it. You don't have to get all hot and sweaty, trying to get the varnish or paint off … you are just 'keying' the surface so that

the tiles will stick. If it has layers of oil, polish or gunge on it, wipe the wood down with spirits before sanding. If the item you are making is going to be exposed to the elements, particularly water, it is best to use marine ply.

NOTE: In order to protect your work, we suggest that you always seal the wood before applying the tiles. And if the item is going to hang outside, it's a good idea to use primer and enamel paint on the undecorated areas to ensure that there's no swelling and contracting of the wood, which will eventually lead to tiles popping off.

Glass

Unlike some wood, this is a very stable base, although not if you drop it of course! As mentioned earlier, under **ADHESIVES** (unless you are decorating the inside and the outside) you should use an adhesive that is transparent, like silicone. The other thing to take into account is the amount of use the item is going to get. For instance, a bowl that is going to be used for fruit should have a little more 'grout protection' than a bowl that is purely ornamental, so you would add waterproofing sealant to the grout instead of water.

Pottery and bisque

This is also a stable base and if you happen to know a potter, not only will you be able to get bowls

or suchlike from there, you may even be able to get specific tiles made up as well. Luckily, we have a pottery and mosaic studio nearby and it's been a great help because they have produced bases and tiles to our specifications, which makes the process a whole lot easier. Once again, remember that anything that is going to be exposed to water needs extra protection.

Cement

Whether it's a table, a pot or a stepping stone, there is no sounder surface. Normally these items are outside, so you will have to use waterproofing sealant in the grout. These items are normally available at hardware stores and plant nurseries. If you already have one and you want to decorate it, make sure that it is clean and mould-free before you start working on

it. Scrubbing it with bleach, then rinsing it and leaving it to dry will do the trick.

Other bases

There is a selection of other bases, like metal and fibreglass, for instance. Some may need priming or sanding (or both) to ensure that the tiles adhere properly. Once you've done some mosaic work, you'll have an idea of what needs to be done to prepare the surface. When in doubt, ask for help at your local hardware store as they are normally a bit better at this sort of thing than differentiating between adhesives.

SAFETY

We have to admit that we are pretty slack when it comes to sticking to these rules ourselves, which probably explains the amount of bloodshed. So … if you don't want to cut your fingers on a regular basis, step on shards of glass with bare feet and try and coax tile pieces out of your dog's throat, we suggest that you take at least some, if not all, of the precautions mentioned below:

1. Wear a face mask and goggles when cutting glass and ceramic tiles as the shards can be hazardous. Or you could hold and cut the tile under water in a bowl, if you want to be extra cautious or prefer not to wear the goggles and mask.

2. You should also wear a mask when mixing grout and when sweeping up to prevent yourself from breathing in fine cement dust.

3. When working with grout, use rubber gloves. We don't, but you should! The reason being that it gives you protection if you are using your hands to spread the grout, both from cutting yourself to preventing your nails and fingers from being slightly stained and dehydrated. The latter two problems do go away within a day or so, but if you can get used to working with gloves, it's better to use them.

4. Clear up between sessions to avoid someone getting hurt on shards of glass that may be lying around. Always use a soft bristled brush and dustpan to clean up, not your hands!

5. It's best not to let animals or small children into the room when you are working on a mosaic.

6. Do not wash excess grout down the sink (even we avoid this one – which makes us a little bit concerned as to where our priorities lie). However, don't do it because grout is cement and it will set, even if there is water coming down the pipes every so often. Don't think that you can wash it away with loads of water because some of it will settle in the bends of the pipes and before long, you'll be calling a plumber (who will look at you like you're an idiot when he finds out what you've done).

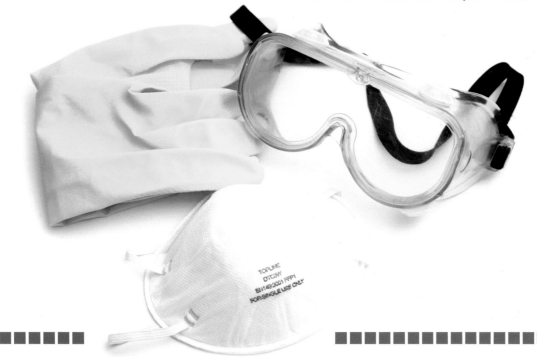

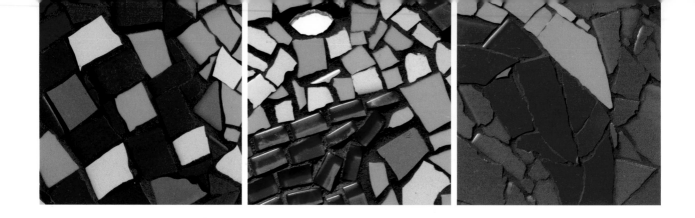

techniques

■ ■ ■ ■ ■ ■ ■ ■ ■ ■ ■ ■ ■ ■ ■

As mentioned in the beginning of the book, all of our projects are done using the direct method. Therefore the techniques explained in this chapter are based on that approach. This means that the tile pieces are stuck directly onto the base and you can clearly see your design taking shape.

CUTTING

■■

What can we say? The main thing is, "Don't be scared". We've noticed that many new students are a bit nervous when faced with any sort of unfamiliar cutting tools, like craft knives or tile nippers. We are sad to say that this normally applies to women only, probably because males love to play with sharp objects! Don't fret about precision cutting – this is not decoupage or scrapbooking. A mosaic is viewed as a whole picture, not as perfectly cut little pieces. However, you do have to have some control over your cutting, so we're giving you a few tips. Practise on cheap tiles, rather than the more expensive ones. You'll find that the longer you do mosaic work, the easier the cutting becomes. You will also discover your own techniques in the process. We have given you instructions using the different cutters, but you'll soon find out which one/s suit you best. If you still feel nervous, put on your protective gear (that should make you feel better) and let's get started…

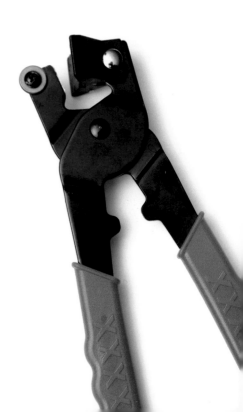

Squares and rectangles

USING NIPPERS: Place your nipper halfway down the edge of the tile, at a 90 degree angle. Hold the tile in your other hand and then squeeze firmly on the handles of the nipper. You should be left with two rectangles. Repeat the process on the rectangles if you want squares – you now have four of them.

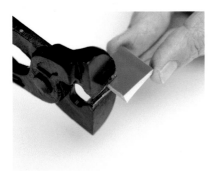
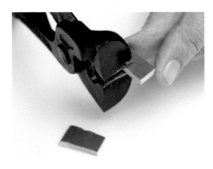
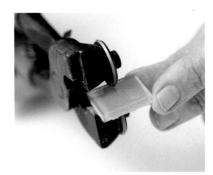

USING GLASS SCORERS OR SCORE-AND-SNAP TOOL: Score across the middle of the tile. You need to press hard to avoid having to repeat the process. Place the scored line directly in the middle of the 'snapper' part of the tool. Press the handles of the tool together firmly to break the tile and use a ruler and pencil to measure and make marks on opposite sides of the tile. With these marks as a guide, score the tile from one side to the other, using the scorer and a ruler. Use this method to create squares and rectangles.

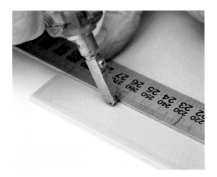
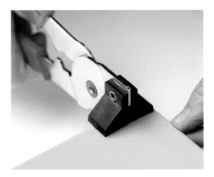
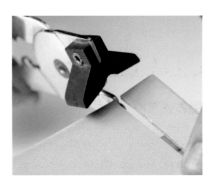

Triangles

USING GLASS SCORERS OR SCORE-AND-SNAP TOOL: You could also use a cutter or nipper here but you are likely to end up with only one decent triangle, which may still need a bit of nibbling to get it right. That's why we prefer to use the scorer. Score the tile from one corner to the other, remembering to press hard. Place the scored line directly in the middle of the snapper and press the handles together firmly.
NOTE: if you don't press firmly enough, you could crack the corners off the tile.

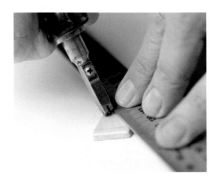
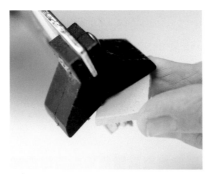
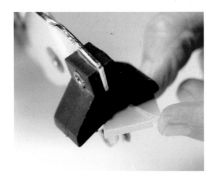

Circles

USING NIPPERS: Use whichever tool you are most comfortable with to cut the circles. They may seem difficult to cut but they're actually quite easy. Draw the circle onto the tile and 'nibble' around the edges to create the shape. In this case, you don't need to press down too much as a gentler approach is needed.

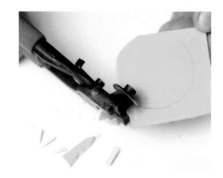

Curves and other shapes

USING NIPPERS: It's a good idea to draw the shape onto the tile but you may prefer to do it freehand if you're not looking for too much precision. To cut a curve, place the nippers on the edge of the tile – turned to the angle you need – and cut away from the curve. You might find that you need to 'nibble' the edges to create the shape that you want.

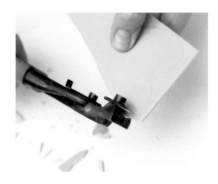

Breaking plates

Place a terry cloth on a hard surface and put the plate (upside down) on top of it, covering it with a second cloth. Feel for the ridge of the plate and, using the hammer, hit around this ridge in order to break the plate into manageable pieces. Lift up the towel every now and again to see how you are progressing; you should be left with fairly large pieces. Decide where you would like the rest of your breaks, recover with the cloth and continue hitting (and checking) until you've got the sizes than you want.

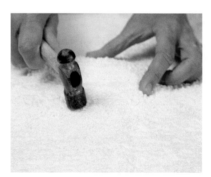

HANDY HINTS

- Remember that the glass scorer has a handle that should be filled with oil before you start working. Don't fill it with water (or nothing) because it really doesn't work very well without the oil. Cooking oil is fine.
- If you are using the scorer and a ruler, make sure that the ruler you use has a cork backing. This will prevent it from slipping on the tile or scratching it.
- When cutting shapes from a large tile, rather cut it into smaller pieces first, which are easier to handle.
- When using the scorer, you will need something to do the snapping. You would normally use running pliers but they seem extremely hard to get hold of in this country, so you'll have to buy a score-and-snapper and use the 'snapping part' of the tool to do the job.

GLUING

■■■■■■■■■■■■■■■■■■■■■■■■■■■■■■ ■■■■■■■■■■

There are a few options here, which we discussed under adhesives. We suggest that you try them and see what works for you. When we first worked with mosaic, we used PVA/wood glue. However, we seldom use it these days, preferring to work with the flexible tile adhesive. We might occasionally use it when working with glass but, quite frankly, we're more inclined to use silicone. Don't discount the wood glue altogether though because you might find that you prefer it. And, as far as kids are concerned, it's always better to let the young ones work with this glue because they're inclined to make an awful mess out of the tile adhesive and silicone, neither of which is easy to clean!

Applying adhesive to the tiles

A small amount of flexible tile adhesive is 'buttered' on to the back of the tile, using either a palette (or kitchen) knife, a toothpick or whatever works for you. We seem to use toothpicks more often than not but if you are working with fairly big pieces, it makes sense to use a knife. Press the tile into position on the base and, if you need to, clean away any excess glue that squeezes up the sides, using a toothpick.

If you are working with tiles that are attached to a netting backing, there is no need to remove them from the backing unless you want to use only one tile or you want wider gaps between tiles. If neither of these apply, cut (through, and including the netting) the amount of tiles you need – a square or a row. Apply adhesive to the back of the tiles, turn the row over, lay down in position and press firmly on each tile to stick it. This is a great, quick way of ensuring even gaps between the tiles. However, don't cut your squares or rows too big because they can become difficult to manage, plus the glue starts drying too quickly. We prefer to work on sections no bigger than approximately 10 cm x 10 cm.

This flexible adhesive is also good when you're working with tiles of different thickness: you can put a little extra adhesive on the thinner tile to give it height and then don't push it down as firmly as the thicker tiles, thereby levelling your work.

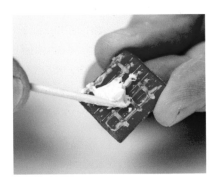
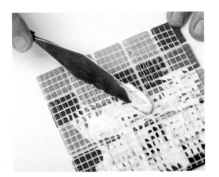
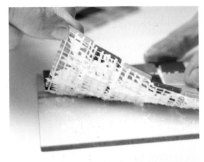

Applying adhesive to the base

You can use either wood glue or flexible tile adhesive for this technique. Apply an even amount of glue to a small area of the base and gently push the tile into it. If excess glue comes up the sides of the tile, remove it with a toothpick. This is another way of evening out the surface when you are working with tiles of different thickness – however, you will have to use tile adhesive, rather than wood glue. Don't use this method on glass unless you're using silicone as it gets too slippery and messy!

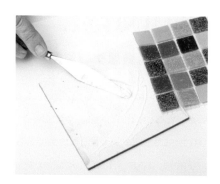

PVA/wood glue used as an adhesive

Ensure that you are using the quick-drying variety. A small amount of this waterproof glue can be applied directly to your base or onto the back of the tile. The glue normally comes in a bottle with a narrow funnel-like top, so application is easy: simply squeeze out a little blob onto either the tile or the base and press the tile into position. Clean up any excess glue around the tile with a toothpick.

Clear silicone used as an adhesive

This is great for use on glass because it is clear so cannot be seen from the undecorated side of your base. We normally use a toothpick to apply the silicone to the back of the tile. Squeeze out a small blob of silicone and scrape it off the top of the tube with a toothpick. Place the toothpick with the silicone down onto the back of the tile and gently roll the toothpick in your fingers. The silicone should remain on the tile as you pull the tooth-pick free. Press the tile firmly into position and clear up any excess silicone with a toothpick.

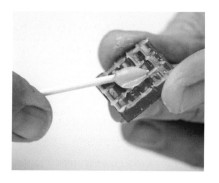

HANDY HINTS

■ When using the flexible tile adhesive, take a little out of the tub at a time, put it on an old saucer (or the lid of an empty ice cream container) and replace the lid of the adhesive, pushing it down firmly. This adhesive is expensive and dries fairly quickly so, if you work directly from the tub, you are going to have dried out adhesive in no time!

■ The method described to apply silicone to the back of the tile by rolling your toothpick can also be used to apply tile adhesive.

■ If you are working with really small tile pieces, it's normally easier to apply the adhesive directly to the base (using the 'toothpick roll') and then place the tile on top of the adhesive using a pair of tweezers.

■ If working with a knife, or anything that is not disposable, make a point of cleaning it once you have finished working. You may even need to clean it whilst you are working because when it gets covered in dry adhesive, it's not easy to use. You may have to use another knife to dislodge adhesive that is stuck firmly to your knife, but be careful when doing so to avoid stabbing yourself.

GROUTING

■■■

When it comes to mosaic work, there are two kinds of people: those who love grouting because they feel that it brings everything together and those who hate it. Okay, maybe hate is too strong a word; extreme dislike would cover it. We fall into the latter category, so we'll have all these pieces sitting around, waiting to be grouted and we'll eventually get round to doing the whole lot at once, but don't think, for one minute, that we actually enjoy it! It really is stupid because grouting is probably the easiest part of making a mosaic. Christopher thinks we're nuts because it's the final step that brings it all together and is his favourite part of the process. Perhaps it's just us … maybe you will love it! At the risk of sounding like a stuck record, you need to take into account where the mosaic is to be displayed. If it is doing to be subjected to any kind of moisture, or lots of use, remember to replace the water with waterproofing sealant when mixing the grout. It's a little more difficult to work with but it's worth the extra trouble.

Preparing the surface

Use a paintbrush to brush over the item you are about to grout in order to remove any tile shards or fragments. This will normally also alert you to any tiles that are loose, in which case you'll have to reglue them and wait a while for them to dry before beginning to grout.

Mixing grout

Do this according to the manufacturer's instructions on the packet. However, if you have bought one of those small packs that don't include instructions, the basic way of doing it is as follows: put the water into a bowl first, then add the grout, mixing it to the consistency of thick cream. Rather start off with less water, adding more should you need to, than too much which will result in the mixed grout having more in common with milk than thick cream! The way to remedy this is to just add more grout, however if you are working with the little packs, there may not be any more to add.

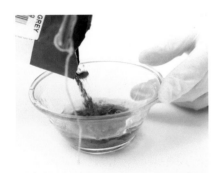 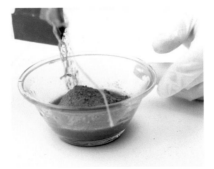 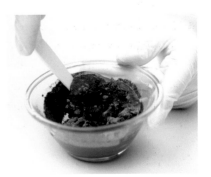

Applying grout

This is when you should wear gloves. If you are worried about getting dirty hands and nails, or you prefer to use your fingers to apply the grout and stand a chance of slicing them with sharp edges, or you're the kind of person who could possibly be allergic to the grout, then put them on! We are risk-takers (or plain dumb) when it comes to crafts so we never wear gloves.

Use a grouting squeegee or an old credit card to apply the grout, pulling it firmly across the surface, and then down it, to ensure that it settles properly into the gaps. If you are working on a small surface you can use your fingers to apply the grout. Clean off as much excess off the top of your tiles as you can, using one of the applicators. Leave it to dry for about an hour. If it still seems very wet, leave it a little longer.

Cleaning excess grout

The grout should have only just started to set – the surface feels dry to the touch. Don't leave it to dry completely, otherwise you make things difficult for yourself. Take a dense sponge, dip it in water, squeeze out as much water as you can, and remove the excess grout from the tiles by wiping the sponge across them. Use each side of the sponge only once before rinsing and squeezing again, otherwise you will end up re-applying grout that you have already taken off.

Polishing

Once the grout has dried properly, you will also notice a thin, powdery residue of grout on the surface of the mosaic. Polish it with a dry, lint-free cloth, removing this thin coating.
If you need to clean the tiles of bits of stubborn grout and adhesive, try using vinegar. If this doesn't work you can use brick or cement cleaner. Be warned though – this is diluted hydrochloric acid so take care and follow the manufacturer's instructions.

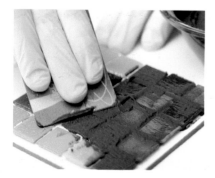
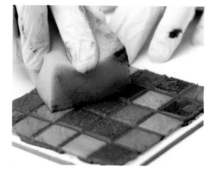
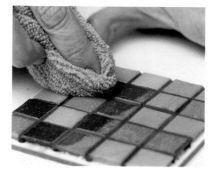

What colour grout?

This can be a bit daunting at first but once you've done a few pieces, you'll have an idea of what you prefer. Here is some basic information to help you with your choice:

White can be very stark, but works well if you have a lot of white tiles and you want them to blend together; it can break up the dark tiles though, making it difficult to see the design properly. However, when working with whites and pastels, it can also be subtle and feminine.

Black is fairly dramatic and tends to intensify the colours of the tiles. It also seems to add a stylish, more masculine, look to the mosaic. Grey is the 'safe bet' as it is normally fairly neutral, unifying your work. Choose a light to medium grey.

The other neutrals work pretty much in the same way as the grey, provided you choose the right neutral for your work.

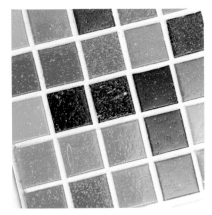
white

black

grey

neutral

HANDY HINTS

■ You can use mosaic tile adhesive, which is a grout/adhesive combination but it's normally used for the indirect method. It's stronger than normal grout, because of the glue in it, and can be used purely as a grout, especially if you are going to have wide joints. It's a little rougher and a bit more difficult to work with than standard grout but it won't crack.

■ These days you can also buy ready-mixed waterproof grout, however, it isn't available everywhere and, quite frankly, it's easy to mix your own using waterproofing sealant.

■ We don't throw away the excess grout left after grouting an item, we cover it with plastic (so it doesn't harden too quickly) and wait until we've given our mosaic its first clean with a sponge. That way, we can fill in any bits we may have missed or inadvertently removed with the sponge. Then we throw it away.

■ Don't leave unused grout in a bowl (that you intend using again) for more than a few hours. It will set solid and you may end up having to throw away the grout and the bowl!

projects

We've tried to bring you a selection of different projects, most of them being practical and stylish objects (we hope!) that you can keep in your home or use as gifts. With all our crafts we've aimed to make them look more like something you would find in a home store, than at a "Look-I-made-this-myself!" fête. And before you think that might sound a bit snobbish, it's not meant to: we have a certain style and naturally try to adapt the craft to that style. However, we are well aware of the fact that people have different tastes, which is why we try to include a variety of projects to suit those tastes. Perhaps the colours are too subdued for you – you may well prefer something a lot bolder or brighter. Not to worry, you can follow our instructions but simply change the colours. We've found that it's a lot easier for crafters to envisage copying something (but adding more decoration and colour) than it is to picture simplifying it!

The projects are written in a step-by-step format that you should find easy to follow. Once you start working through various projects, you will notice that some of the steps are repetitive. We decided that we wanted you to be able to choose any project and begin working on it, without having to refer back to other sections of the book. Obviously, you may need to turn back to refresh your memory as far as some of the basic techniques like cutting, gluing and grouting are concerned, because we had to draw the line somewhere. We hope you enjoy getting stuck into the projects and that you can learn from our mistakes, which we always try to include in order to make life a bit easier for you.

BOXED LAMP

■■

We first came across one of these when we went to visit a local tile making/mosaic teaching studio. We were really taken with it and decided immediately that we had to have one for this book. A whole lot of different glass embellishments were used, like beads, handmade tiles and pebbles, which we managed to accumulate. Then we had to learn how to make a boxed lamp, which was easier than we thought it would be.

The next stage was to get a base and put a working bulb in it. Luckily, one of our children is a budding electrician so we handed it over to him and he did it for us. And then, finally, we could begin working on the really important stuff – making it look pretty.

YOU WILL NEED

4 pieces of glass 18 cm x 15.5 cm (sides)

1 piece of glass 15 cm x 15.5 cm (top)

Clear silicone

Old picture frame for the base

Lamp socket and bulb

Hardboard approx 18 cm x 15.5 cm

Paint

Paintbrush

Medium-grit sandpaper

Felt-tip pen

Pebbles – various sizes and colours

Handmade glass discs – 4 large and 1 small

Toothpicks

Various sized green beads

Small square glass tiles (green and blue)

Wheeled nippers

Glass tiles (orange and mustard)

Charcoal grout

Old credit card

Lint-free cloth

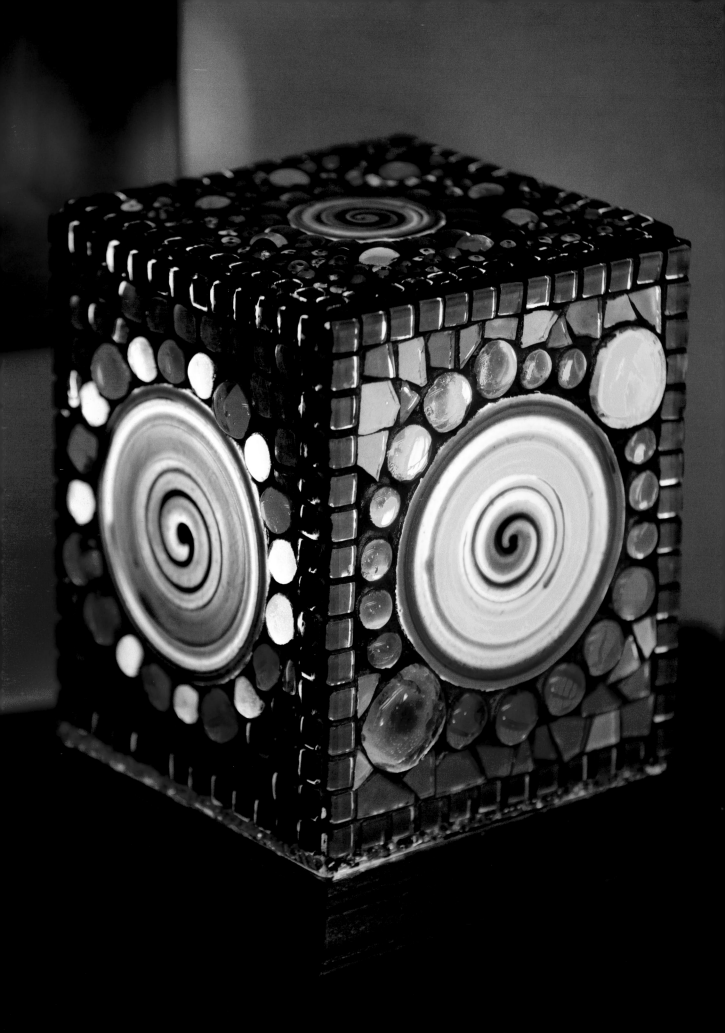

TO MAKE THE BOX: Glue two pieces of glass together (18 cm x 15.5 cm) using silicone and leave to dry. Then glue the other two sides together in the same way and leave to dry. Now glue these two pieces together to make a square glass box and once again leave to dry. Put silicone on the top edges and press the smaller piece of glass on to form a lid.

MAKING THE BASE: Ensure that your picture frame is fractionally bigger than the box (if it's a lot bigger you can make it smaller by taking it apart and cutting it down a bit; if it's smaller, you've got a problem!) Put a piece of hardboard in the recess that the glass would normally sit in and glue or nail it in position. Make a hole in the centre of the hardboard in order to fit the socket and bulb – the hole is for the electrical wire to come through.

If you work with an old frame, sand it down to remove old varnish. Once this is done, paint the sides with 1 coat of paint and, when dry, sand lightly before applying 2 more coats, allowing drying time between them.

Place the glass box onto the frame so that you can see how much of the bottom edges of the box sit in the frame – mark that area with the felt-tip pen as it will not be decorated. Find the middle of each glass side and, using a toothpick to apply the silicone, glue all five glass discs in place. Now glue a circular frame around each disc, using various sized pebbles. Once that is done, stick the outer frames around the edges.

Fill the gaps in between the inner circles and outer frames with glass tile chips (cut them using a wheeled nipper), small pebbles or beads. Clean away excess silicone with a toothpick and leave overnight to dry.

Mix the tile grout according to the manufacturer's instructions and apply it, using the applicator and your fingers. Once you have finished grouting, leave it to dry for about an hour. Then take the sponge, dip it in water and squeeze it until it's almost dry. Wipe it gently over the top and edges of your work in order to smooth the grout and also wipe away the excess from the surface of the tiles. Keep cleaning the sponge as you work but ensure that you squeeze out as much water as possible each time you do so. Leave it overnight to dry and then buff with a lint-free cloth.

HANDY HINTS

■ If you use your fingers for grouting, be careful when working around the glass chips – they can be very sharp.

■ Keep checking the position of your glass tiles and pebbles as you work – because you are putting glass onto glass they can slide a little until the silicone is a bit drier, so you may need to readjust here and there.

■ We only made our frame after we'd decorated the glass box, so we had a bit of bare glass showing once we'd put the glass into the frame. This was easily remedied by gluing small glass beads in this section, using silicone. No need to grout.

PEBBLE AND GLASS BOWL

■■

Those of you who've read our previous books will know that, because they are so popular, we always feature a bowl or two. Although we both work on them, there is one person in this partnership who has become the Bowl Queen and this is another of her creations.

We used one of those recycled-glass bowls for this project, which was fairly quick and easy to complete once we'd decided on a design. The underside of the bowl can be left as is but we didn't like the look of the bottom of the tiles, so we covered it in serviette paper and painted it to give it a professional finish.

YOU WILL NEED

Glass bowl

Blue glass tiles

White wood glue (quickset)

Green glass pebbles

Green glass tiles

Score-and-snap tool

White grout

Waterproofing sealant

Old credit card

Firm sponge

Lint-free cloth

White acrylic paint

Foam applicator

White paper serviettes

Water-based varnish

Craft knife

Use the blue tiles (placed diagonally) to begin laying a border on the lip of the bowl, ensuring that you leave enough space between them for grouting. Glue the tiles down by applying a little wood glue onto the back of each piece and pressing it into position.

Glue the green pebbles between the tiles using the same method.

Use the score-and-snap tool to score and cut enough green tiles for the rest of the border and glue them into position to complete it.

Working around the bowl in a circular motion, begin gluing the blue tiles one row at a time. When starting a new row don't try to match up the tiles with the ones above; rather stagger them to

ensure that you don't end up with uneven spacing. Continue gluing down the tiles in this way until you have reached the bottom of the bowl. Fill in the space at the base of the bowl by gluing down green tiles and droplets. Leave to dry overnight.

Mix the tile grout according to the manufacturer's instructions,

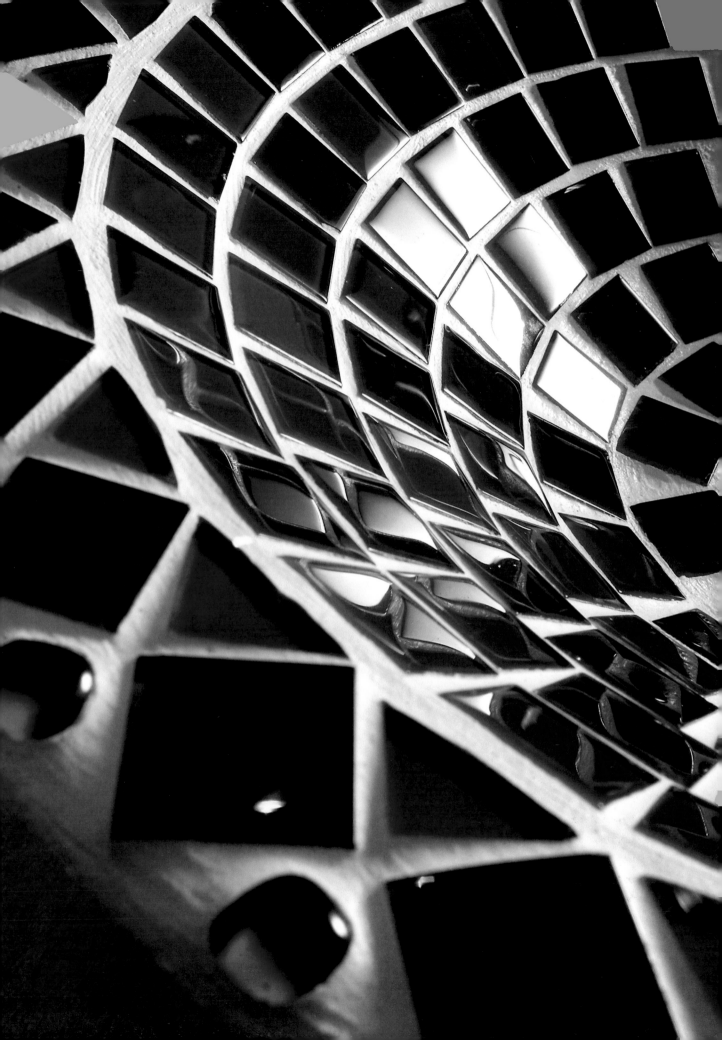

replacing the water with water-proofing sealant, and apply using the credit card. Once you have finished grouting, leave it to dry for about an hour. Then take the sponge, dip it in water and squeeze it until it's almost dry. Wipe it gently over the top and edges of your work in order to smooth the grout and also wipe away the excess from the surface of the tiles and pebbles. Keep cleaning the sponge as you work but ensure that you squeeze out

as much water as possible each time you do so. Leave it overnight to dry and then buff with a lint-free cloth.

Paint the underside of the bowl with 2 coats of white paint, allowing drying time between coats. Separate the layers of the serviette (only one layer at a time will be used) and tear into strips. Lay the strips over the painted area and begin 'gluing them down by dabbing over them using varnish

and a foam applicator. Continue applying the strips in this manner, slightly overlapping the pieces as you work around the bowl. When dry, trim away excess paper with a craft knife.

Apply two more coats of white craft paint over the papered area, allowing drying time between coats. Seal with 2 coats of varnish to complete.

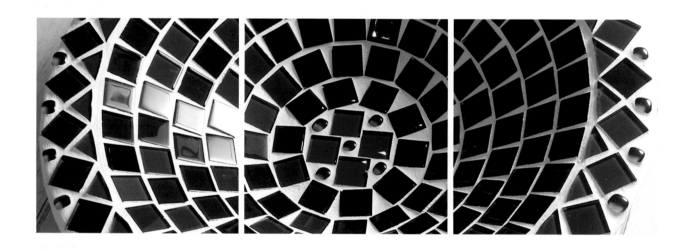

HANDY HINTS

- Once you have applied glue to the tiles, wait at least a minute before sticking them down for it to become tacky otherwise the tiles will slide down the bowl.
- If you forget to mix sealant with the grout, you can put it on once you have finished – follow the manufacturer's instructions for applying waterproofing grout.
- Once you have started gluing down a row of tiles, continue without a break until you have completed the row because you may have to manoeuvre some of the pieces to make the design work – this can't be done if the glue has dried.

FLOWERY MAGAZINE RACK

Dare we admit that this is one of our old decoupage items that has been given a facelift? Luckily, Geoff doesn't notice too much (apart from the TV) so there was no lamenting from him when we started reworking the decoupage items that had been in the Boomer house for years.

This was originally one of those forty coats of varnish items and we reckoned that the quickest way to get paint on it without having to sand it down first would be to use lacquer spray paint. It worked like a dream. We're assuming that you are starting off with raw wood, so will give the instructions accordingly …

YOU WILL NEED

Wooden magazine stand

Grey acrylic paint

Paintbrush

Medium-grit sandpaper (optional)

Ruler

Soft pencil

Glazed blue ceramic tiles

Glazed red ceramic tiles

Wheeled nipper

Tile adhesive

Palette knife

Glazed yellow off-cuts

Glazed black off-cuts

Glazed green off-cuts (light and dark)

Glazed brown off-cuts (light and dark)

Glazed orange off-cuts

Light grey grout

Grout applicator

Firm sponge

Lint-free cloth

Flower and ladybird embellishments

Silicone

Paint the inside and outside of the stand (apart from the area you'll mosaic) with grey acrylic paint. If it feels slightly rough after the first coat, sand it lightly before applying subsequent coats. You will probably have to give it about 2 – 3 coats, allowing drying time between them.

Measure and divide the front of the stand into four equal areas, discounting the top section where the curve is. In other words, measure from the bottom of that curve – don't include the area above it. Mark these divisions with pencil lines and sketch flowers in each of them.

Cut the red and blue tiles into rectangles and glue them down to form visual dividers/frames.

NOW WORK ON THE FLOWERS: drawing petals and circles where needed, and using the wheeled nippers to nibble around the design until you get the desired

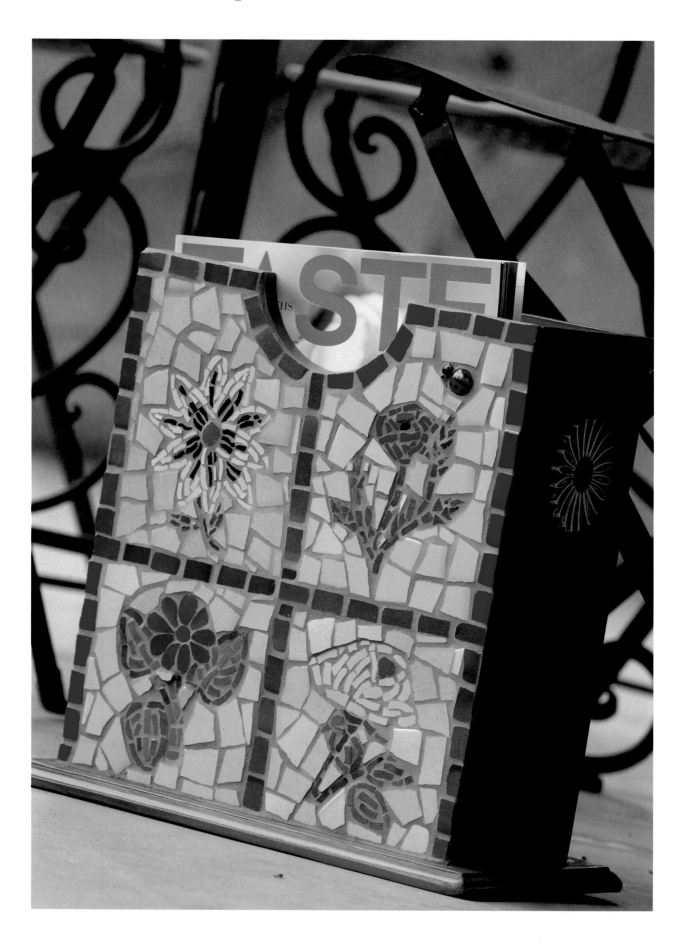

shape. Glue them and the ladybird down using the adhesive. Cut small rectangles from your coloured off-cuts and begin gluing them down, following the pencilled lines.

Once you are done, cut bigger, irregularly shaped pieces of the grey tiles – try to keep them more or less the same size. Glue them down and leave overnight to dry.

Mix the tile grout according to the manufacturer's instructions and apply using the applicator. Once you have finished grouting, leave it to dry for about an hour. Then take the sponge, dip it in water and squeeze it until it's almost dry. Wipe it gently over the top and edges of your work in order to smooth the grout and also wipe away the excess from the surface of the tiles. Keep cleaning the

sponge as you work but ensure that you squeeze out as much water as possible each time you do so. Leave it overnight to dry and then buff with a lint-free cloth.

Use a small blob of silicone to glue each of the embellishments to the sides of the magazine stand.

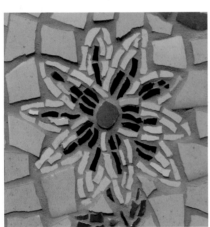 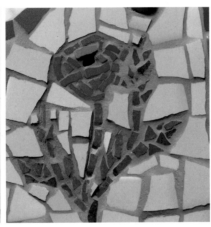 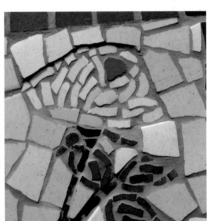

HANDY HINTS ■

- Download images off the internet or trace them from books if you aren't good at drawing. Children's colouring books have some great pictures for mosaic.
- If you decide to use spray paint, work in a well-ventilated area (not outside in the wind though) and keep the can moving as you spray, otherwise you end up with runs.

GEOMETRIC FIREPLACE

■■■

When we installed this closed-unit cast-iron stove a few years ago we didn't think that we'd have a problem with falling embers damaging the wooden floor. However, having two young boys who insisted on opening the door to stoke the fire, gaze at the fire and wonder what else they could burn in there (crayons, golf balls, Barney the cat) very quickly led to little black marks appearing all over the floor. A mosaic surround for the fireplace not only sorted out the problem of the burning floor; it also enhanced the décor of the room. We applied the mosaic to a piece of hardboard instead of directly onto the wooden floor, which is prone to movement, and then glued it to the floor.

YOU WILL NEED

Plywood or hardboard cut to size
Glazed red ceramic tiles
Ruler
Glass scorer
Score-and-snap cutter
Glazed cream ceramic tiles
Glazed black ceramic tiles
Tile adhesive
Palette knife
Wooden quarter round
White wood glue (quickset)
Light grey grout
Old credit card
Firm sponge
Lint-free cloth

Cut enough red rectangular tiles to go all the way around the outer edge of the wooden base and lay them. Use the glass scorer and a ruler to score the tiles and then snap them with the score-and-snapper. Cut cream tiles into quarters and lay these pieces at a 45 degree angle (so they look diamond-shaped) 1 cm away from the red tiles. Repeat this pattern all the way around. You now have a row of cream tiles next to the red ones.

Cut and lay another row of red rectangular tiles alongside the cream ones, once again leaving a 1 cm gap. Finish off the border by cutting enough black tiles into triangles to fill in all the gaps between the red and cream tiles. Complete the mosaic layout by cutting sufficient cream tiles into quarters to cover the entire inner section. You will have to adjust the tiles accordingly to ensure even spacing.

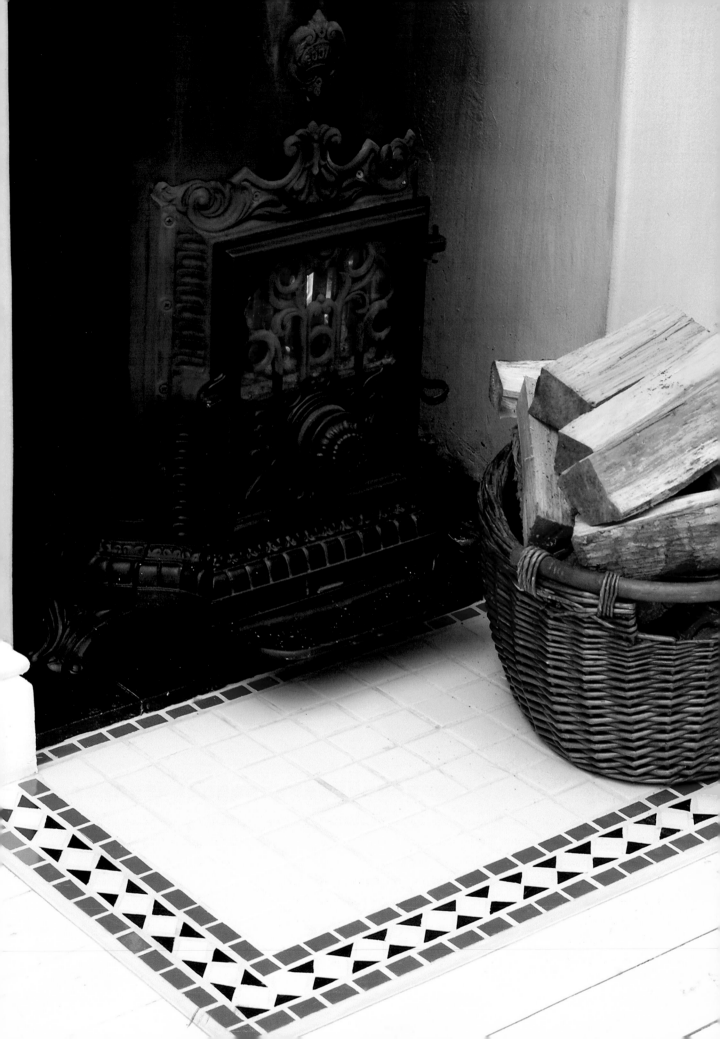

Begin gluing the pieces by buttering tile adhesive onto the back of each one, using the palette knife, and pressing it down in its original position. Work methodically, starting once again from the outer edges and working inwards. Once completed, leave to dry for 24 hours.

Mitre the edges of 3 pieces of quarter round and glue it around the mosaic using wood glue. Mix the tile grout according to the manufacturer's instructions and apply using the credit card. Once you have finished grouting, leave it to dry for about an hour. Then take the sponge, dip it in water and squeeze it until it's almost dry. Wipe it gently over the top and edges of your work in order to smooth the grout and also wipe away the excess from the surface of the tiles. Keep cleaning the sponge as you work but ensure that you squeeze out as much water as possible each time you do so. Leave it overnight to dry and then buff with a lint-free cloth.

HANDY HINTS ■■■

- You could hire a tile cutter if your tiles are really thick and you're giving yourself a hernia by trying to score them with the glass scorer. If you aren't sure how to use the equipment, ask. The assistants at tool-hire places are there to show you how it's done.
- Take care that the tiles are straight and evenly spaced once you have glued them down – sometimes a crooked tile isn't noticeable until it's been highlighted with grout.

■■

ASIAN BIN

■■■

This is another one of the base items that we redecorated. Deborah's husband, Christopher, got a tad upset about it because he liked it the way it was. We managed to appease him by saying that we were trying to be cost-effective and save money. He grumbled a little more, saying something along the lines of, "It's a great pity, it's not going to look as nice blah, blah …" but left it at that. We rolled our eyes (which is not awfully mature, we know) and got to work. When we had finished with it, he looked at it with surprise and said, "Do you know, I actually like that." We would have hit him with it but we were worried about damaging the tiles.

YOU WILL NEED

Wooden bin

Medium-grit sandpaper

Black acrylic paint

Paintbrush

Glazed pottery head

Tile adhesive

Palette knife

Toothpicks

Copper and black glass tiles

Score-and-snap cutters

Black vitreous tiles

Charcoal black grout

Grout applicator

Firm sponge

Lint-free cloth

If you are using a previously decorated base, sand the entire thing to get rid of any loose paint or varnish. You don't have to sand it right down to the wood. All you need to do is key the surface so that the adhesive and paint stick to it. Apply one coat of paint to the areas that won't be decorated with tiles and leave to dry. If the wood feels a little rough after this coat, sand it lightly and apply another 2 – 3 coats, allowing drying time between them.

Find the centre of one of the sides of the bin and glue the head in place, using a fair amount of adhesive because it's quite heavy. Push it down firmly, removing any excess adhesive that has squeezed up around the sides with a toothpick. Now position and stick a row of the copper/black tiles at the bottom and top of the area to be decorated, working from the outsides inwards, cutting the last tile to fit if necessary. Use these same tiles to make a frame around the head, cutting some of them down in order to keep the central image balanced.

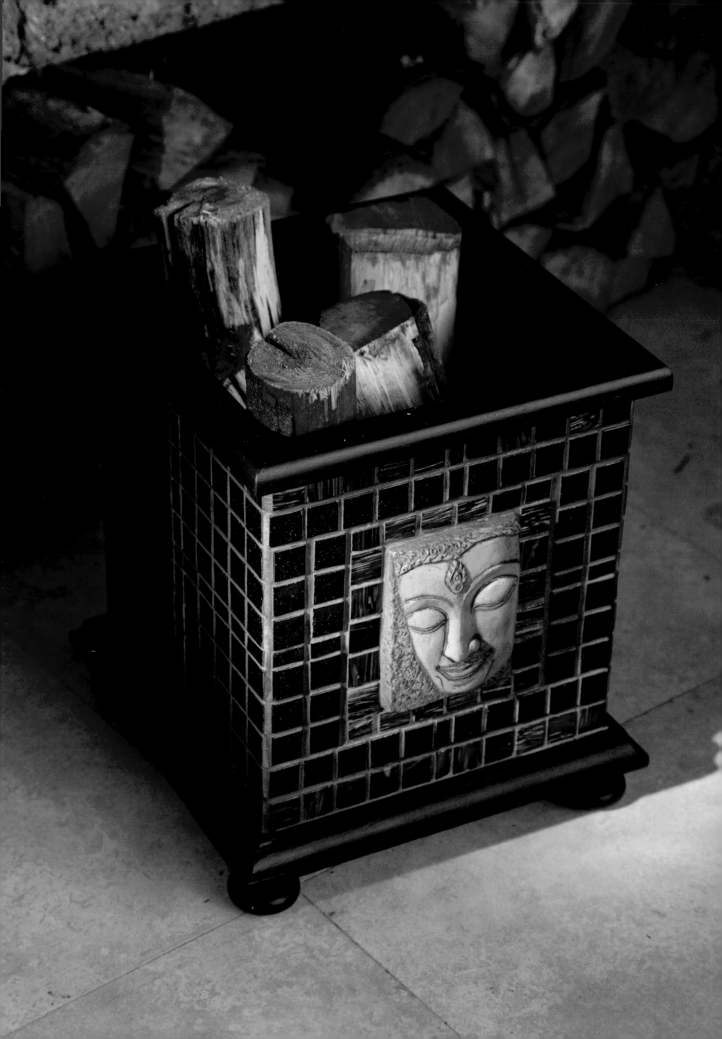

Start gluing the black vitreous tiles in place, working from the outsides inwards and from the bottom and top towards the middle. This ensures that any tiles that need to be cut smaller because there isn't enough space for a full tile will be placed in the centre, making a more balanced design.

Repeat the process on the remaining three sides (without the head, of course), working towards the centre and cutting the tiles down if necessary. Once everything is glued in place, leave overnight to dry.

Mix the tile grout according to the manufacturer's instructions and apply using the applicator. Once you have finished grouting, leave it to dry for about an hour. Then take the sponge, dip it in water and squeeze it until it's almost dry. Wipe it gently over the top and edges of your work in order to smooth the grout and also wipe away the excess from the surface of the tiles. Keep cleaning the sponge as you work but ensure that you squeeze out as much water as possible each time you do so. Leave it overnight to dry and then buff with a lint-free cloth.

HANDY HINTS

■ The copper/black tiles are pretty expensive but, by mixing them with cheaper, vitreous tiles, we have managed to get three projects out of one sheet.
■ If you use an old bin that has gloss paint, oil or heavy varnish on it, you will probably need a little more than a light sanding to prepare it. Wipe it down with spirits to remove gunge, sand and then apply a coat of universal primer before using the black paint.

GREEN CIRCLE PLATTER

■■■■■■■■■■■■■■■■■■■■■■■■■■■■■■■■■■■■■■■

Although this was a fast and easy project as no cutting needed to be done, there was a downside to it: the tiles were more than a little expensive. In fact the word 'outrageous' springs to mind when we think about the cost. However, every now and again it's good to treat yourself to something round, pretty and sparkly, so if you look at it that way, it's a lot cheaper than a diamond ring …

The glass tiles and chips were the same thickness, so the finished item is really smooth and, as a waterproofing sealant is used, it can be both decorative and functional.

YOU WILL NEED

Glass platter

Pre-cut opaque white glass tiles

Clear silicone

Toothpicks

Mesh mat of round and chipped glass tiles

White grout

Waterproofing sealant

Grout applicator

Firm sponge

Lint-free cloth

Starting with the square opaque tiles, stick them around the edge of the platter, using a toothpick to apply a small amount of silicone to the tiles before pressing them into position. Leave to dry because you will have to stick another layer directly on top of those ones to raise the height of the border (the round tiles are about twice as thick as these ones). Once grouted, it really makes quite an interesting border.

As the round and chipped tiles come attached to mesh which you would normally use as is, you will have to remove them and redesign the pattern in order for them to work on the platter. Start by gluing the large circles down first; move on to filling in with the smaller ones and, once you are happy with that, you can use the chips to fill in the other gaps. Leave overnight to dry.

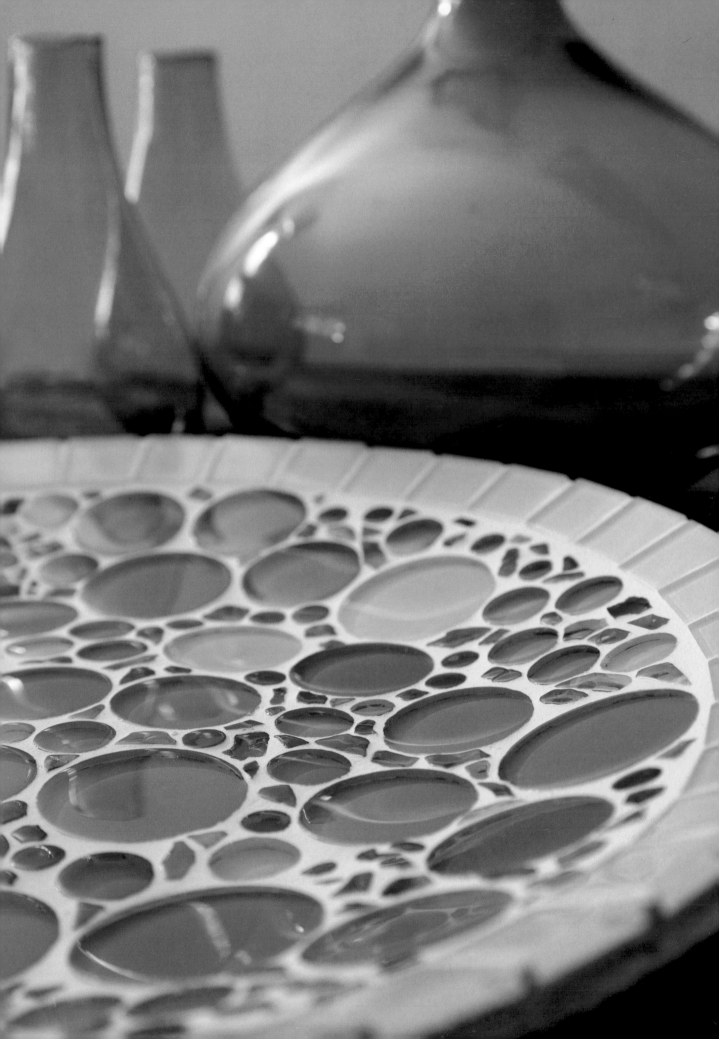

Mix the tile grout according to the manufacturer's instructions, replacing the water with waterproofing sealant, and apply it using the applicator. Once you have finished grouting, leave it to dry for about an hour. Then take the sponge, dip it in water and squeeze it until it's almost dry. Wipe it gently over the top and edges of your work in order to smooth the grout and also wipe away the excess from the surface of the tiles. Keep cleaning the sponge as you work but ensure that you squeeze out as much water as possible each time you do so. The sealant makes it a little bit harder to clean up but it's worth it for its waterproofing properties. Leave overnight to dry and then buff with a lint-free cloth.

 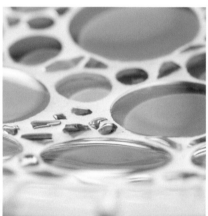

HANDY HINTS

- Work carefully with the silicone, trying not to get it on the top of your tiles. The best way to apply it is to squeeze out a small blob and scrape it off the top of the tube with a toothpick. Place both the toothpick and silicone down on the back of the tile and gently roll the toothpick in your fingers. This ensures that the silicone is transferred neatly to the tile.
- Don't, under any circumstances, let your husband know how much you paid for these tiles! And if you are the husband, we think you have a very lucky wife (but don't tell her how much they cost, just to be on the safe side).
- If you are a pro when it comes to using the wheeled nippers, you could make your own circles by nipping away at a square tile.
- Sometimes when applying glass tiles to a glass base, the tiles can slide a little. If this happens, readjust them until the silicone is a bit drier.

GLITZY FISH

It was while browsing through a market in Johannesburg with a friend that we came across a local artist who was selling various objects made of metal. The fish caught our eyes because we had just bought some glitzy, almost iridescent tiles which we immediately thought would make perfect scales.

The fish we bought is made of some kind of metal that is covered in a weird oily type of coating so we knew we would have to do something about that before we could begin gluing …

YOU WILL NEED

Metal fish (or other object)

Spirits

Turquoise glass tiles

Clear silicone

Toothpicks

Wheeled nippers

Turquoise glitter tile

Glitzy iridescent tiles

Purple glass tiles

Scissors

Gold tiles

Charcoal black grout

Old credit card

Firm sponge

Lint-free cloth

Bulb socket

Blue bulb

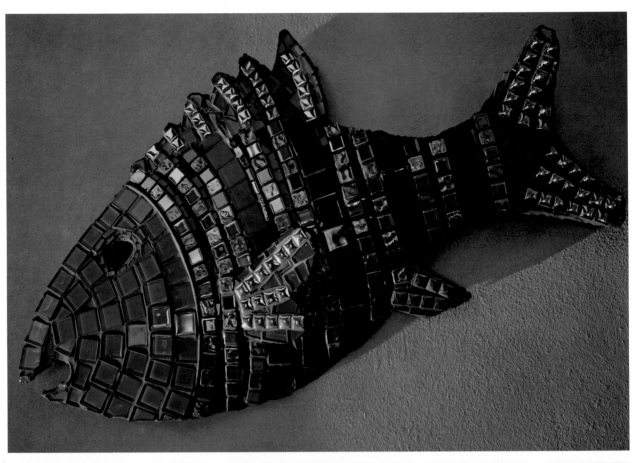

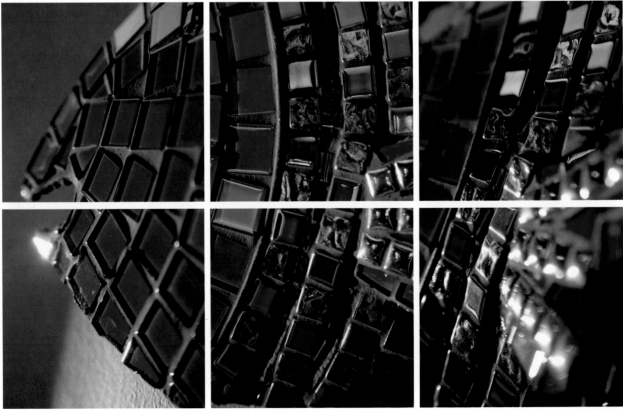

Wipe the outside of the fish with spirits and then sand in order to key the surface, thereby ensuring adhesion of the tiles.

Start working on the fish's head by following the ridge that separates it from the rest of the body, working from the top of the head to the bottom. Use silicone and a toothpick to glue the glass tiles along that ridge, cutting the last one to fit. Now glue a row along the top of the fish's head, once again cutting the tiles down when you reach the mouth. Continue to work from the back of the head to the front, placing the tiles in a curve and cutting them down where necessary – leaving a little extra space around the eye for the glitter tile pieces.

Cut the glitter tile into small pieces and glue them around the eye.

Don't remove the glitzy and purple tiles from their netting; it will be easier to use them if you cut them into strips. Lay and glue the tiles down in rows, alternating them every now and again, and cutting them into smaller pieces where necessary (you'll have to remove them from the netting when you do that).

Once you reach the tail of the fish, glue down rows of gold tiles and then cut the turquoise glass tiles into pieces and fill in the gaps. Do the same thing on the fins and leave overnight to dry.
 Mix the tile grout according to the manufacturer's instructions and apply using the applicator. Once you have finished grouting, leave it to dry for about an hour. Then take the sponge, dip it in water and squeeze it until it's almost dry.

Wipe it gently over the top and edges of your work in order to smooth the grout and also wipe away the excess from the surface of the tiles. Keep cleaning the sponge as you work but ensure that you squeeze out as much water as possible each time you do so. Leave it overnight to dry and then buff with a lint-free cloth.

Secure a bulb socket and bulb to the back of the fish using silicone and insulation tape. If you are not sure how to do this, you could take it to a hardware store and they'll help you – or ask your teenage son (like we did).

HANDY HINTS ■■■

■ The fish had thin open gaps here and there along its body and that's what gave us the idea of putting a light behind it but if you'd rather not do that, leave out the last step.

■ Don't tile and grout over the gaps because they make the body fairly flexible, so you could end up with grout cracking and tiles falling off if you cover them!

■■

LAZY SUSAN

■■

We weren't too sure whether people actually use these anymore but we came across it in a craft shop amongst all the other decoupage blanks and were told that they are still popular. Debbie refuses to have one though, because every time she and Christopher go somewhere where there is one, he spends the whole lunch hour playing with it. He's especially fond of spinning it the minute he sees someone reaching for it! She and their daughters are so looking forward to the day he eventually grows up.

Don't worry if you are hopeless at drawing, as there are loads of lovely stencils on the market that make transferring designs very easy. We wanted to keep the colour combination fairly subtle so that it wouldn't end up looking overly fussy once it was covered in condiments and surrounded by crockery.

YOU WILL NEED

Wooden Lazy Susan
Black acrylic paint
Paintbrush
Medium-grit sandpaper (optional)
Soft pencil
Ruler
Dinner plate
Side plate
1 large swirl stencil
1 small swirl stencil
Lime green glazed ceramic tiles
Glass scorer filled with oil
Score-and-snap tool
Wheeled nippers
Green glazed ceramic tiles
Tile adhesive
Palette knife
Grey glazed ceramic tiles
Light grey grout
Grout applicator/credit card
Firm sponge
Lint-free cloth

Paint the edge of the Lazy Susan with black acrylic paint. If the edge feels slightly rough after the first coat, sand it lightly before applying subsequent coats. You will probably have to give it about 2 – 3 coats, allowing drying time between them.

Place the dinner plate in the centre of the Lazy Susan and draw around it using the pencil (a ruler helps you ensure the plate is in the middle). Remove the dinner plate and replace it with the side plate, also placing that in the middle – once again using your ruler to get the position right and the pencil to draw around it. You now have two drawn circles: the larger one makes up the lime-green border and the smaller one the grey centre of the design.

Use a pencil and the large swirl stencil to draw the design on the outer section. Now use the same stencil and draw another swirl opposite the first one, turning the stencil upside down to balance the design. Draw another set of large swirls opposite each other, in between the first two; then fill those gaps with small swirl designs.

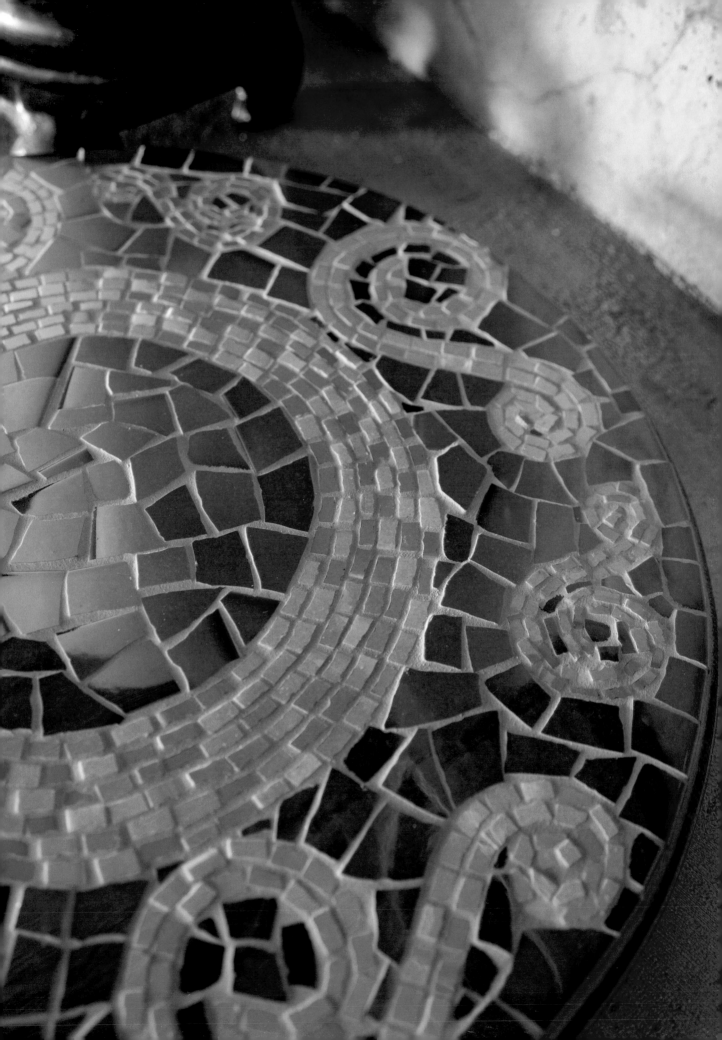

Use the ruler and pencil to measure and make marks, 1 cm apart, on opposite sides of the lime green tile. With your pencil marks as a guide, score the tile from one side to the other, using the glass scorer and a ruler. Take the score-and-snapper and snap the tile on the scored line, producing a tile strip, which you then cut into smaller pieces using the wheeled nippers. Try to keep them approximately the same size.

Begin sticking down tile pieces on a large swirl, working from one end to the other, and completing all four swirls. Repeat this process on the smaller swirls, using a different green tile, which is cut in the same way, only the pieces are slightly smaller.

Cut the grey tiles into irregular shapes of approximately the same size (using the wheeled nippers) and begin filling in around the swirls, taking them up to the pencil line of the large circle. Now complete this circle by cutting both green-hued tiles in the same way as you cut the pieces for the swirls. Stick the pieces in place, working around the circle and then moving inwards. When this is done, complete the inner circle with the grey tiles, using the same technique you used on the outer edges.

Mix the tile grout according to the manufacturer's instructions and apply it using the credit card. Once you have finished grouting, leave it to dry for about an hour. Then take the sponge, dip it in water and squeeze it until it's almost dry. Wipe it gently over the top and edges of your work in order to smooth the grout and also wipe away the excess from the surface of the tiles. Keep cleaning the sponge as you work but ensure that you squeeze out as much water as possible each time you do so. Leave it to dry and then buff with a lint-free cloth.

HANDY HINTS

■ In order to give our work a neater look, we used the straight, outer edges of the tiles on the outer edges of the Lazy Susan.

■ We extended the grout over the painted edge to soften the black, which would have been too harsh. This is a quick way of creating a 'paint finish'.

■ You may find that tweezers and toothpicks come in handy when working with the little tile pieces.

WILLOW PATTERN TRAY

■■

Those of you who have been married for a long time will know that men become a tad grumpy as time goes by and, sometimes, it's fun to taunt them just a little bit, to make up for all that grumpiness you have to endure. These willow pattern plates were just the thing, so when Tracy brought home three of these plates that she'd bought from a junk/antique shop, and proceeded to smash them in front of Geoff (who is a purist and loves old china), she had a good cackle to herself at the expression on his face.

Well, the plates did actually cost a small fortune, and perhaps we should have tried to find some chipped ones but then it's not always a perfect world, is it? Anyway, we saved money on the tray, which was old and battered, so it kind of evened out in the end.

YOU WILL NEED

Wooden tray

Medium-grit sandpaper

White acrylic paint

Paintbrush

3 willow pattern side plates

Ruler

Soft pencil

2 terry cloths

Hammer

2 boards (optional)

Tile adhesive

Palette knife

Wheeled nippers

White glazed ceramic tiles

Side biters

Dove grey grout

Old credit card/grout applicator

Firm sponge

Lint-free cloth

If you work with an old tray, like this one, sand down the outer and inner sides of the tray to remove old varnish. Once this is done, paint the sides with 1 coat of white paint and, when dry, sand lightly before applying 2 more coats, allowing drying time between them.

Measure the tray lengthwise and draw a line down the middle, dividing it in two in order to help you with the positioning of the plates. Take one of the plates and place it to the left of the line and draw around it. Do the same thing to the right of the line, but bear in mind that once you've broken and reconstructed the plates your 'plate size' will be slightly larger because of the gaps, so make allowances for this.

BREAKING PLATES: Place a terry cloth on a hard surface and put the plate (upside down) on top of it, covering it with a second cloth. Feel for the ridge of the plate and, using the hammer, hit around this ridge in order to break the plate into manageable pieces. Lift up the towel every now and again to see how you are progressing: you should be left with fairly large pieces. Decide where you would like the rest of your breaks, recover with the cloth and continue hitting (and checking) until you've got the sizes than you want.

Before you start gluing you may want to turn the pieces over; we

found that it's a lot easier to work with the decorative pieces facing you. In order to do this, you need to 'sandwich' both the cloths and their contents between 2 boards, slipping one board under the bottom cloth and another on top, hold them firmly, and flip the whole lot over.

After removing the board and cloth, you can start gluing. Place the outer edge pieces down first, leaving gaps between them (using the drawn circle as a rough guide only).

Once you're happy with the placement, you can glue the pieces down using tile adhesive. When the outer rim is finished, move inwards and glue the central pieces in place, ensuring that the picture is lined up properly. Repeat with

the plate on the other side. The third plate couldn't fit comfortably (or at all) in the available space, but we certainly weren't going to let that stop us! We simply cut the outer edges down to about a third of their original size, using the wheeled nippers. In this instance we started gluing from the middle of the plate, working outwards so that we could get the spacing and sizing right. When you complete the inner circle, stop and move on to the ceramic tiles.

Use the side biters to cut the tiles, firstly cutting small pieces to form a border around the inner circle of the plate, and then adding the smaller outer edges to complete the design. Once that is finished, cut the rest of the tile pieces into squares (more or less) and begin gluing them down around the

plates. Every now and again, you will have to cut a specific shape to fill a space. Continue working in this way until the background is complete. Leave overnight to dry.

Mix the tile grout according to the manufacturer's instructions and apply it, using the applicator or credit card. Once you have finished grouting, leave it to dry for about an hour. Then take the sponge, dip it in water and squeeze it until it's almost dry. Wipe it gently over the top and edges of your work in order to smooth the grout and also wipe away the excess from the surface of the tiles. Keep cleaning the sponge as you work but ensure that you squeeze out as much water as possible each time you do so. Leave it overnight to dry and then buff with a lint-free cloth.

HANDY HINTS ■■

- ■ Don't try to break the plate by hitting it in the middle, as it will shatter and the ridge will be left intact.
- ■ The broken china can be very sharp, so take care not to cut yourself or, if your name is Tracy, start every project with a packet of plasters nearby.
- ■ Ensure that you don't glue your pictures upside down as this is easily done and yes, we know you can just turn the tray the other way but we're talking about having one plate facing in the opposite direction to the rest!
- ■ Only break (and work with) one plate at a time to avoid a lot of confusion over pieces and their placement.

■■■

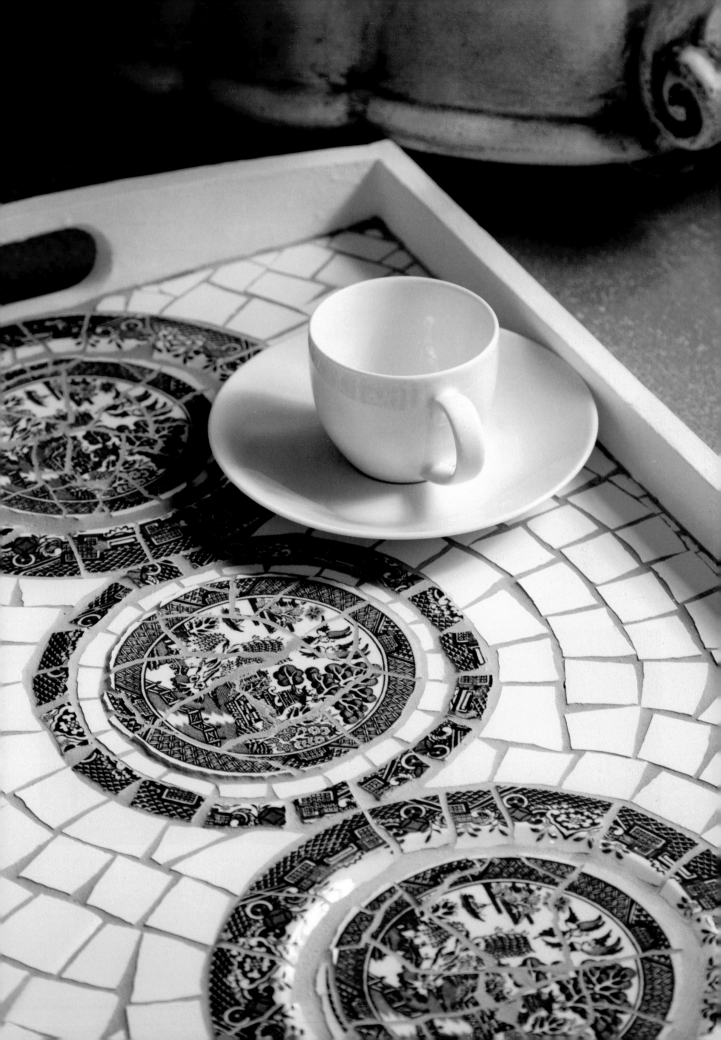

IRIDESCENT CANDLE HOLDER

The problem with asking your craft partner and publisher to help you come up with an introduction to a project is that you would be far better off asking the dog. They mentioned something about a bohemian love nest and things went completely downhill from there …

This project looks pretty simple and straightforward to do but it turned out to be one of the more frustrating ones, so don't start with this if you've never done any mosaic work in the past. It's not difficult but it takes patience.

YOU WILL NEED

Glass candle holder/hurricane lamp

Glass pebbles

Clear silicone

Toothpicks

Iridescent glass tiles

Charcoal grout

Old credit card

Firm sponge

Lint-free cloth

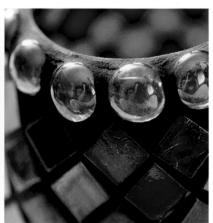

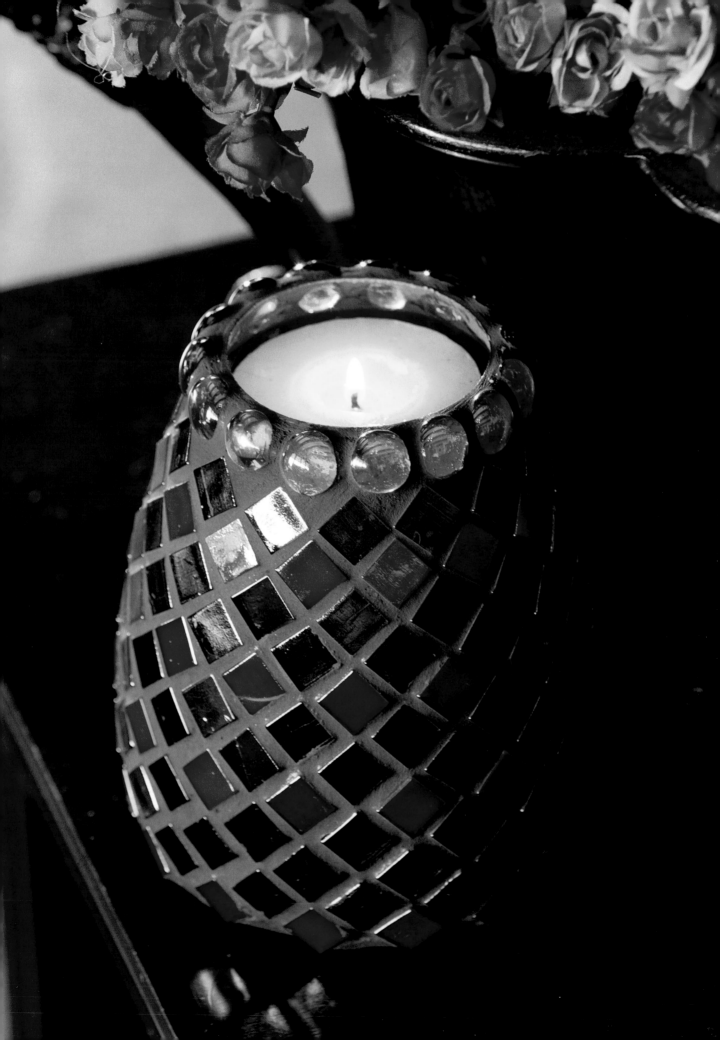

Glue a row of pebbles around the top of the candle holder using the silicone, adjusting the distance between them if necessary once you have gone all the way around.

Now glue a row of tiles underneath the pebbles, turning them so that they are placed diagonally, and work around the holder. Glue another row of tiles underneath this one, slotting the tiles in between the ones above them. Continue in this way until you have reached the bottom. The tiles do slide a bit (though not as much as you would think) so as you are working, you need to go back every now and again and make adjustments.

Mix the tile grout according to the manufacturer's instructions and apply it using the credit card. You will have to use your fingers around the pebbles because using the card is impossible. Once you have finished grouting, leave it to dry for about an hour. Then take the sponge, dip it in water and squeeze it until it's almost dry. Wipe it gently over the top and edges of your work in order to smooth the grout and also wipe away the excess from the surface of the tiles. Keep cleaning the sponge as you work but ensure that you squeeze out as much water as possible each time you do so. Leave it overnight to dry and then buff with a lint-free cloth.

HANDY HINTS

- Don't be tempted to try and mosaic a section on one side instead of working around the holder in rows. We tried this – it doesn't work.
- Working with silicone may be more difficult that using tile adhesive, but you have to use it on glass if the bottom of the tiles will be visible.
- If you don't have mirror silicone, any other clear silicone will be okay because you are not working with mirrors.

GLASS AND PEBBLE CANDLE HOLDERS

Sometimes the simplest things take the longest time. As in the case with the Iridescent Lamp, these two little candle holders created a lot of frustration, but hopefully we can pass on some pointers to make it easier for you.

The larger holder was fairly easy but a little time-consuming. However, the frustration levels were extremely low, so we didn't mind that it took a while. The three holders work really well together – and make a very cheap, but pretty, gift set.

YOU WILL NEED

2 small glass candle holders

1 medium glass candle holder

Brown glass tiles

Orange glass tiles

Wheeled nippers

Clear silicone

Toothpicks

Orange glass pebbles

Beige glass pebbles

White grout

Old credit card

Firm sponge

Lint-free cloth

MEDIUM-SIZED CANDLE HOLDER

Use the wheeled nippers to cut the red and brown glass tiles into small, irregular shaped pieces, keeping them approximately the same size. Apply a blob of silicone to the holder and smear it over a small area using the side of a toothpick.

Press the glass chips firmly into the silicone to glue them down, working in sections until you have covered the entire candle holder. Leave to dry.

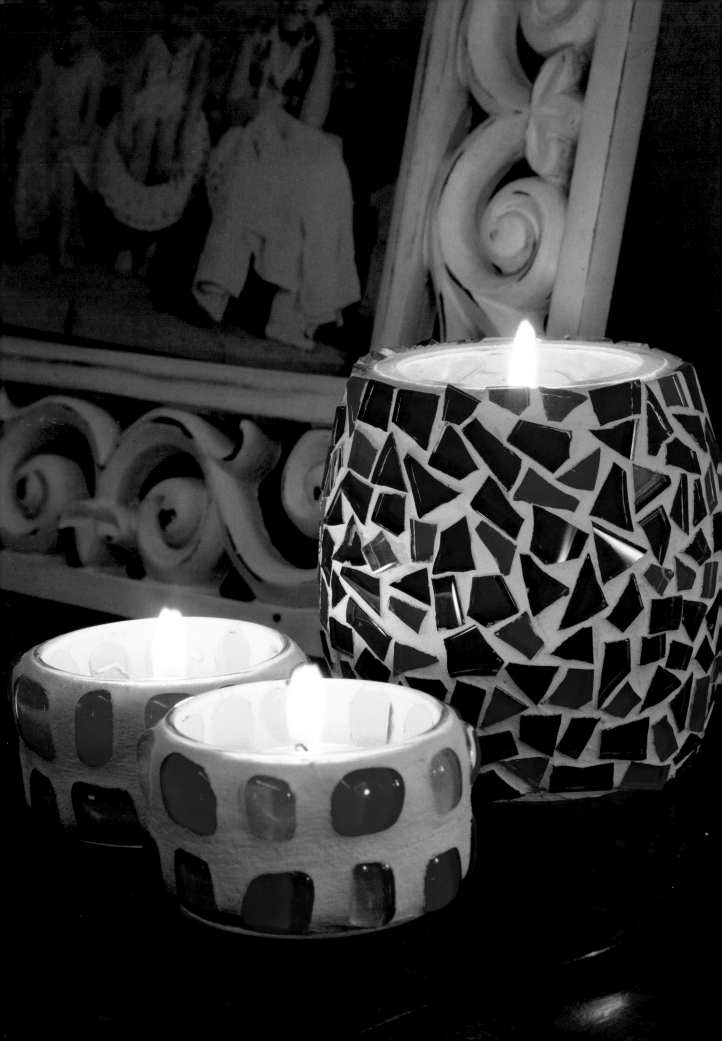

SMALL CANDLE HOLDERS

Apply a small blob of silicone to the back of a pebble, using a toothpick. Press it firmly into position and move on to the next one, alternating colours and gluing one pebble vertically and the other one horizontally.

Continue around the holder until you have completed the circle and repeat with a second row. You'll probably have to adjust the pebbles as you work because they do tend to slide a little. Leave to dry.

ALL THREE CANDLE HOLDERS

Mix the tile grout according to the manufacturer's instructions and apply using the credit card for the larger holder and your fingers for the smaller ones. Once you have finished grouting, leave it to dry for about an hour. Then take the sponge, dip it in water and squeeze it until it's almost dry.

Wipe it gently over the top and edges of your work in order to smooth the grout and also wipe away the excess from the surface of the tiles. Keep cleaning the sponge as you work but ensure that you squeeze out as much water as possible each time you do so. Leave them overnight to dry and then buff with a lint-free cloth.

HANDY HINTS

■ You will probably have to use your fingers to apply grout over the top of the larger candle holder in order to get a decent finish. Take care (or wear gloves) because the edges are sharp.

■ Don't use too much silicone under the pebbles because it causes them to slide more.

■ Don't use mosaic tile adhesive (the one that is an adhesive and a grout) or add waterproofing sealant to normal grout. It may seem like a good idea as common sense dictates that it would probably make the grout stick to the glass better. Maybe it does, but cleaning it is extremely frustrating because it's a lot stickier!

EASY GLASS TABLE MATS

■■■■■■■■■■■■■■■■■■■■■■■■■■■■■■■■■■■■■

These are so simple to make, especially if you want to ease yourself into mosaic work and don't feel that you are quite ready for cutting. Three types (and sizes) of glass tiles were used for each place mat, and we made four of them. Obviously that's not going to be enough for a huge dinner party, so make extra if the budget allows or just make a few and use them in the centre of the table for hot bowls or dishes. The most expensive tiles in this project are the small gold glitter ones in the corners and, as you can see, we've only used a few. So not only are we cutting down on costs but, especially when it comes to gold, we've always felt that less is definitely more.
The cheapest tiles were the vitreous ones in the centre, which was something of a relief because we needed quite a few of them!

YOU WILL NEED

4 wooden table mat bases

Black acrylic paint

Paintbrush

Medium-grit sandpaper (optional)

Soft pencil

Ruler

Gold glitter glass tiles (small)

Orange glass tiles

Black vitreous glass tiles

Scissors

Tile adhesive

Palette knife

Toothpicks

Charcoal grout

Grout applicator

Firm sponge

Lint-free cloth

Paint the sides and back of the place mats using the acrylic paint. If the wood feels slightly rough after the first coat, sand it lightly before applying subsequent coats. You will probably have to give them at least 2 – 3 coats, allowing drying time between coats. When they are completely dry, turn them over, right-side up, so that you can begin laying the tiles.

Use the ruler to find the centre of the place mat and mark it with the pencil. Draw a horizontal and then a vertical line down the middle to make it clearer. If your tiles are all attached to netting, cut out what is needed but leave the tiles at-tached to the netting in strips (or squares), which automatically gives you equal spacing between tiles.

Lay the tiles that make up the border first. If you find that the spacing isn't quite right, then cut them from the netting and rearrange them, creating either bigger or smaller gaps between the tiles, using the central pencil markings as a guide.

Once you have laid the border, fill in the middle with the vitreous tiles, which will probably also be attached to netting, once again using the pencil lines to help you with the positioning of the tiles. You may find that you need to adjust the placement of your border slightly to ensure that the gaps between tiles are more or less equal.

Now you can begin gluing, starting with the corners, then the sides and finally the middle. To do this, turn the strip (or square) of tiles over and apply a small amount of adhesive to the back of each tile,

then turn them right-side up and press down on each tile to secure it. When it comes to gluing the middle section, it's easier to cut the mat of tiles into four or more manageable pieces; that way they are easier to handle and you can fiddle around with spacing if you need to. Clean away any excess adhesive that may have crept up the sides of the tiles with a tooth-pick. Repeat the process on the remaining mats and leave over-night to dry.

Mix the grout according to the manufacturer's instructions and apply it, using a grout applicator.

Remove as much grout off the tiles as possible and then leave for about an hour to dry.

Take the sponge, dip it in water and squeeze it until it's almost dry. Wipe it gently over the top of your work in order to smooth the grout and also wipe away the excess from the surface of the tiles. Keep rinsing the sponge as you work but ensure that you squeeze out as much water as possible each time you do so. Leave the grout to dry and then buff the table mat with a lint-free cloth.

HANDY HINTS

■ It's a good idea to replace some, if not all of the water in the grout mix with waterproofing sealant, as the place mats will probably be used and wiped frequently.
■ If you can't get hold of the small tiles like the ones we used at the corners, cut a standard-sized one into quarters. Go on, give it a bash – you'll probably amaze yourself. We did.
■ We painted the back of the place mats but if you want to give them a real professional finish, stick cork underneath.

CHEF CLOCK

■■

This clock was bought at a popular discount homeware store and already had the image of the chef printed on it. This gave us a kind of ready-made base to work on; all we had to do was mosaic over the picture, using the same colours.

The project was fairly time-consuming because we used really small pieces of tile for a good part of it and obviously it takes longer to mosaic a picture than a simple design.

YOU WILL NEED

Clock with image
Ruler
Soft pencil
Cream glazed ceramic tiles
glazed ceramic tiles
Dark brown glazed ceramic tiles
Black glazed ceramic tiles
Green glazed ceramic tiles
Mustard glazed ceramic tiles
White glazed ceramic tiles
Opaque glass tile
Red glass tiles
Glass scorer
Score-and-snap tool
Wheeled nippers
Tile adhesive
Toothpicks
Clear silicone
Oatmeal grout
Grout applicator
Firm sponge
Lint-free cloth

As this project uses a lot of small, rectangular tiles, we thought it best to go over the easiest way to cut them: Use the ruler and pencil to measure and make marks, 0.5 cm apart, on opposite sides of the tile. With your pencil marks as a guide, score the tile from one side to the other, using the glass scorer and a ruler. Take the score-and-snap tool and snap the tile on the scored line, producing a tile strip, which you can then cut into smaller pieces using the wheeled nippers. Try to keep them approximately the same size.

Cut small rectangular pieces out of the white tiles and glue them down over the numbers, using a single piece to mark the position

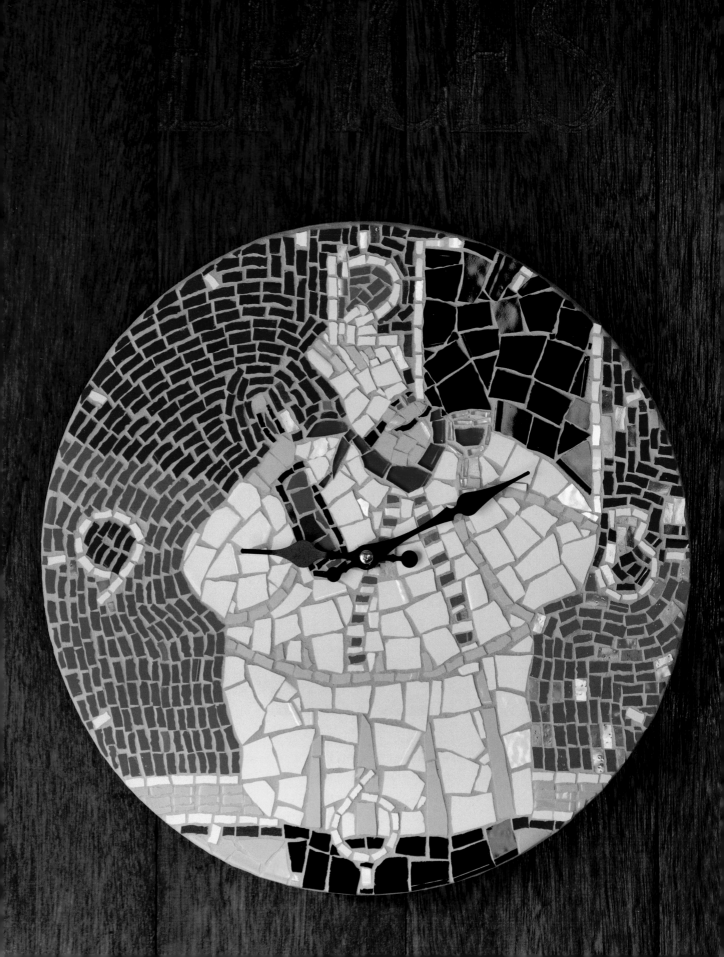

of the numbers that are missing. It's best to use a toothpick to apply the adhesive because the pieces are so small.

Begin working on the chef first by cutting long grey pieces (using the wheeled nippers) and gluing them down with tile adhesive. Now cut small rectangles from the grey and stick those down too. Move on to the buttons, cutting pieces of brown and cream and gluing them in position. Then work on the wine bottle, outlining it in black tiles and filling it in with green ones. The wine glass was done using opaque tile pieces to outline it, which were stuck down with silicone.

Use the red glass tiles for his scarf and the wine in the glass, and glue with silicone. Now use the wheeled nippers to cut irregularly shaped cream tiles of approximately the same size for his clothing. Glue down pieces on the outer edge of his body first, working inwards. The same tiles are used on his hat. Complete his face by first gluing down the pieces to form his moustache, hair and eyebrows, then use mustard tile pieces for his face and hands.

Moving on to his pants, use irregularly shaped black pieces to complete them as well as the blackboard, which will be outlined in small, white rectangular pieces. Use these same small pieces for the row of white tiles in the background at the bottom of the clock and fill in the rest of the space with mustard tile pieces.

To complete the rest of the background, ensure that you have cut plenty of both light and dark brown pieces so that you don't have to stop and cut more every few minutes. Start gluing them down alongside his body so that you get a nice flow going. Work on one row at a time, changing colour when necessary while you move out towards the edges of the clock. When finished, leave to dry.

Mix the tile grout according to the manufacturer's instructions and apply using the applicator. Once you have finished grouting, leave it to dry for about an hour. Then take the sponge, dip it in water and squeeze it until it's almost dry. Wipe it gently over the top and edges of your work in order to smooth the grout and also wipe away the excess from the surface of the tiles. Keep cleaning the sponge as you work but ensure that you squeeze out as much water as possible each time you do so. Leave it overnight to dry and then buff with a lint-free cloth.

HANDY HINTS ■■

- ■ As the pieces are so small, it's a good idea to use tweezers to lift and position them.
- ■ Remove the clock hands before you begin working otherwise you'll get frustrated and they will probably end up covered in adhesive and grout!

■■

TWENTIES-STYLE BLACKBOARD

This blackboard really brings to mind the Roaring Twenties and it's probably due to a combination of the flapper image as well as the design and colours.

This was yet another decoupage conversion – it appeared in our *Decoupage with Serviettes* book and originally had a rooster on it. It also had green triangles (virtually identical to the black ones) down the sides. In fact, we used those triangles as a guide to make a template for the black ones.

YOU WILL NEED

Wooden blackboard base
Black acrylic paint
Paintbrush
Medium-grit sandpaper (optional)
Ruler
Small piece of cardboard
Blue tac
Glazed black ceramic tiles
Glass scorer
Score-and-snap tool
Tile adhesive
Palette knife
Decorative tile
Small black glass tiles
Silicone
Millefiori
Toothpicks
Glazed white ceramic tiles
Side biter
Light grey grout
Old credit card
Firm sponge
Lint-free cloth
Blackboard paint

Paint the edges and back of the blackboard with acrylic paint. If the wood feels slightly rough after the first coat, sand it lightly before applying subsequent coats. You will probably have to give it at least 2 – 3 coats, allowing drying time between coats.

Measure the sides of the blackboard and use this measurement to work out the size of your triangles. Make a triangle template out of cardboard and use a little blue tac to stick it to the black tile. Score the tile around the template, using a ruler to help you keep the lines straight. Now use the score-and-snapper to break the tile, giving you a triangle. Continue in this way until you have cut enough triangles to go up both sides of the blackboard.

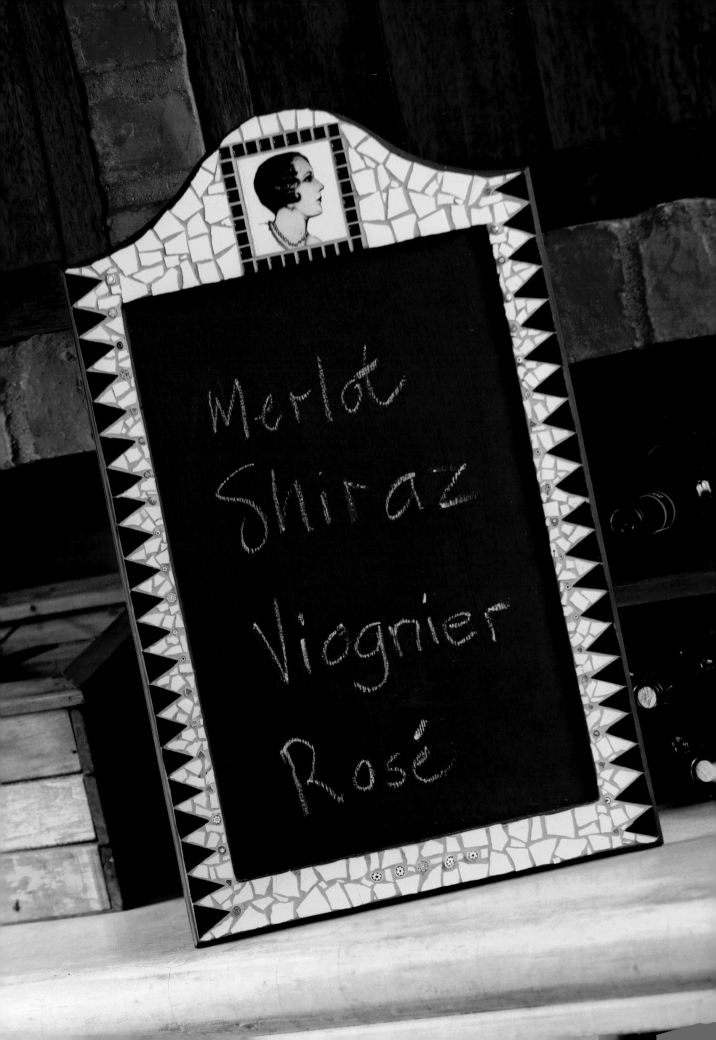

Glue the triangles down on both sides of the board using tile adhesive and ensure that they are positioned very close to each other. Stick the decorative tile in the centre of the top section of the blackboard and glue a glass tile border around it. Use a toothpick to apply a little silicone to the back of the millefiori (one at a time) and stick them at the point of each triangle.

Cut irregular shapes of white tiles of approximately the same size and fill in the background on the top and bottom of the board. Do the same thing for the sides, only make the pieces smaller.

Mix the tile grout according to the manufacturer's instructions and apply using the credit card. Once you have finished grouting, leave it to dry for about an hour. Then take the sponge, dip it in water and squeeze it until it's almost dry.

Wipe it gently over the top and edges of your work in order to smooth the grout and also wipe away the excess from the surface of the tiles. Keep cleaning the sponge as you work but ensure that you squeeze out as much water as possible each time you do so. Leave it overnight to dry and then buff with a lint-free cloth.

Paint 2 – 3 coats of blackboard paint in the middle, sanding after the first coat if necessary and allowing drying time between coats.

HANDY HINTS

■ If you are also redecorating an old piece, you will have to sand it with medium-grit sandpaper before you begin painting or gluing – this keys the surface to accept paint and adhesive.
■ The millefiori are different heights – use a little more silicone to raise the flatter ones.
■ Try using a pair of tweezers to place the millefiori in position because they can be a bit tricky to work with, especially if you are working with silicone as well.

APPLE BOWL

■■■

The Serial Bowl Queen was at it again for this book – there's simply no way of keeping a good bowl decorator down! Anyway, it makes her happy and she does them so well that it's best she gets left alone to complete it until the urge goes, allowing her to move on to other things.

We used a bisque bowl for this project but asked the potter to glaze and fire the outside of it in order to give it more protection (it also meant we didn't have to paint and varnish it …).

YOU WILL NEED

Bisque bowl
Apple stencil or image
Soft pencil
Glazed red ceramic tiles
Glazed brown ceramic tile off-cut
Glazed light green ceramic tiles
Glazed dark green ceramic tiles
Side biters
Tile adhesive
Palette knife
Toothpicks
Tweezers (optional)
Glazed white ceramic tiles
Light grey grout
Waterproofing sealant
Grout applicator
Firm sponge
Lint-free cloth
White paint
Paintbrush

As neither of us happens to be very good when it comes to drawing, we downloaded an apple image off the internet, printed and cut it out, and used that as a stencil to draw the apples onto the bowl. So either do the same, or draw directly onto the bowl. Then, using the side biters, cut the red tiles into similarly sized rectangles.

Follow the outline of the apples using the red pieces and glue them down, working your way inwards until you get to the centre. You will have to cut a few smaller pieces to fill in the larger gaps. Now cut nine small, brown pieces for the stems and glue them down – you may prefer to use a toothpick to apply the adhesive.

Moving on to the leaves, cut small rectangles out of both the light and dark green tiles, and glue them into position. Once the apples are complete, you can begin working on the background. Cut approximately the same sized pieces of white tile and glue them on the inner edge of the bowl, cutting them down where

necessary when they meet with the leaves. Once you have finished, cut random shapes to fill in the rest of the background and glue in place. Leave overnight to dry.

Mix the tile grout according to the manufacturer's instructions, replacing the water with waterproofing sealant, and apply it using the applicator. Once you have finished grouting, leave it to dry for about an hour. Then take the sponge, dip it in water and squeeze it until it's almost dry. Wipe it gently over the top and edges of your work in order to smooth the grout and also wipe away the excess from the surface of the tiles. Keep cleaning the sponge as you work but ensure that you squeeze out as much water as possible each time you do so. Leave it overnight to dry and then buff with a lint-free cloth.

We painted the edge of the bowl, including the top of the tiles, with white paint to give it a more professional finish.

HANDY HINTS

- The first time we grouted this bowl, we used white grout because we wanted the apples to be the focal
- point and thought the white would keep the background subtle. However, the apples ended up being too much of a focal point, with the background disappearing completely, so we regrouted with grey, which worked perfectly.
- We worked with tweezers and toothpicks when gluing the small pieces down because they can be a little tricky to handle.

PIGGY BREAD BOX

■■■

Decoupage blanks, like this bread box, are a great source of base material for mosaic work. We decided that we would only mosaic the lid for a couple of reasons: it would end up being pretty heavy if the whole box was done and … we didn't have enough tiles! But we think it's good that it worked out that way because we wanted the focus to stay on the piggy lid, and that might have been lost if the whole box was done.

We used pre-cut wooden letters for the word BREAD but you could also use a stencil for the lettering.

YOU WILL NEED

Wooden breadbox
Black acrylic paint
Paintbrush
Medium-grit sandpaper
Soft pencil
Ruler
Black glazed ceramic tiles
Glass scorer filled with oil
Score-and-snap tool
Tile adhesive
Palette knife
2 decorative tiles
Red glazed ceramic tiles
Cream glazed ceramic tiles
Wheeled nippers
Wooden letters or a stencil
Dove grey grout
Grout applicator
Firm sponge
Lint-free cloth

Paint the edges and the inside of the bread box with black acrylic paint. If it feels slightly rough after the first coat, sand it lightly before applying subsequent coats. You will probably have to give it 2 – 3 coats, allowing drying time between them. Repeat the process on the outside (sides and edges) and leave to dry.

Starting with the black tiles used for the border, measure and make marks 2 cm apart on opposite sides of the tile. Using these marks as a guide and a ruler to ensure your line is straight, score the tile from one side to the other. Then use the score-and-snap tool to snap the tile along the scored line, producing a strip. Continue until

you have cut the entire tile. Now repeat this procedure on each strip, measuring and cutting them at 2 cm intervals. You now have a collection of square pieces. Cut these squares diagonally in half to produce triangles.

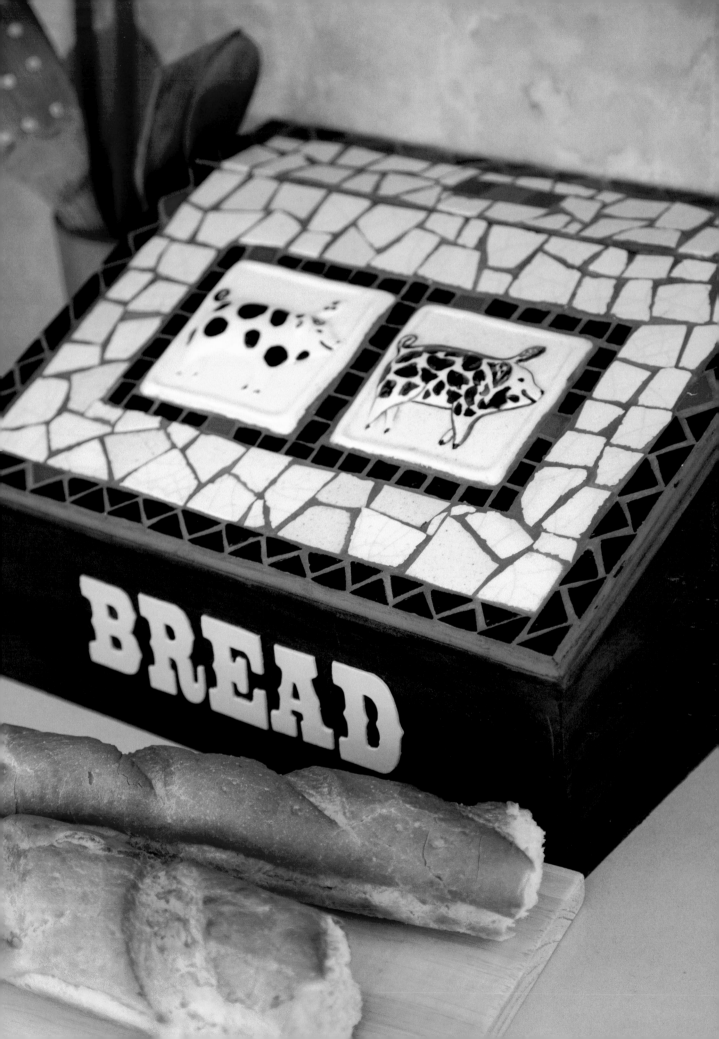

Begin gluing these triangles around the lid, longest side against the edge of it. When done, glue a second row against the first one, turning the tiles so that they fit into each other (we added a few red triangles for effect). Use your ruler to find the centre of the lid and mark it with a pencil. Glue the two decorative tiles down, leaving a gap of approximately 3 cm between them.

Cut rectangular shapes from the black tiles (include a few red ones) and make a border around the decorative tiles, then make yourself three small squares and stick them in the centre of the top of the bread box, just to add a little interest.

Use the wheeled nippers to cut the cream tiles into irregular shapes of approximately the same size. Begin filling in the background, very much like working at a puzzle, using shapes that fit in with each other.

Mix the tile grout according to the manufacturer's instructions, and apply it using the applicator. Once you have finished grouting, leave it to dry for about an hour. Then take the sponge, dip it in water and squeeze it until it's almost dry. Wipe it gently over the top and edges of your work in order to smooth the grout and also wipe away the excess from the surface of the tiles. Keep cleaning the sponge as you work but ensure that you squeeze out as much water as possible each time you do so. Leave overnight to dry and then buff with a lint-free cloth.

Paint and seal the lettering with varnish before gluing in place.

HANDY HINTS

- It's not that easy to always cut exactly the same size triangles, so we found it helped to cut more than we needed to give us a better chance of matching up pieces that are more or less the same size.
- As the bread box has an opening lid, take care not to place the tiles too close to the edges of the sides that have the hinges – if you do, you won't be able to open the lid properly.
- If you have grouted the entire top at the same time, ensure that you cut open the hinged section.

FLOWER POTS

■■

These small pots were originally supposed to be for herbs or flowers but there's only one little problem … they're made of wood so wouldn't last too long once they're in constant contact with moisture – even if there were drainage holes at the bottom – which there aren't.

So you could either get a small plant that is in a pot with a base and put that inside (if it fits) or you could use them in your kitchen to hold utensils. Your other option is to get pottery or stone bases and work on those instead of the wooden ones.

YOU WILL NEED

Wooden flower pots

White acrylic paint

Paintbrush

Sandpaper (optional)

Small green glass tiles

Small red glass tiles

Tile adhesive

Palette knife

Flower embellishments

Toothpicks

Soft pencil

Glazed lime green ceramic tile off-cut

Glazed dark green ceramic tile/s

Glazed red and white ceramic tile/s

Side biters

White grout

Grout applicator

Firm sponge

Lint-free cloth

Paint the inside and top edges of the pots using the acrylic paint. If the wood feels slightly rough after the first coat, sand it lightly before applying subsequent coats. You will probably have to give them at least 2 – 3 coats, allowing drying time between coats.

Glue strips of green tiles at both the top and bottom edges of both pots, working all the way around them until all four sides are done. Add an extra strip of red tiles above the green ones on the bigger pot.

Work out where you want the flower embellishments and glue them down, removing any excess glue from their sides with a toothpick. Use the pencil to draw stems coming down from the flowers.

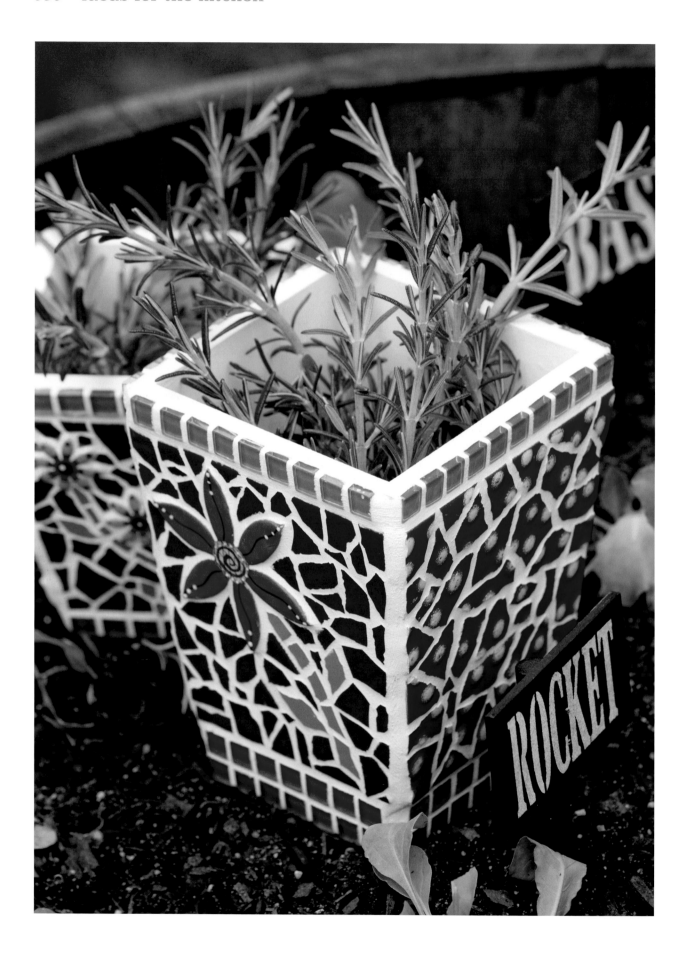

Now use the side biters to cut the lime green off-cut into small pieces and glue them down to make the stems and leaves. Once done, begin cutting and gluing dark green pieces around the flowers, covering the entire front - there is no need to stick to any particular shape or size. When you have finished with the green, move on to the red and white tiles, and work in

exactly the same way, completing all sides. Leave overnight to dry.

Mix the tile grout according to the manufacturer's instructions and apply using the applicator. Once you have finished grouting, leave it to dry for about an hour. Then take the sponge, dip it in water and squeeze it until it's almost dry. Wipe it gently over the top and

edges of your work in order to smooth the grout and also wipe away the excess from the surface of the tiles. Keep cleaning the sponge as you work but ensure that you squeeze out as much water as possible each time you do so. Leave it overnight to dry and then buff with a lint-free cloth.

HANDY HINTS

- Use the natural straight edges of the tile pieces at the top and bottom or your sides (next to the rows of glass tiles). It gives your work a neater finish.
- We only had one of each of the dark green and red and white tiles, so we really couldn't afford any waste. The larger pot has three red and white sides and the smaller one only two (there's a green one at the back).
- Toothpicks are really handy when it comes to removing excess grout from between the petals.

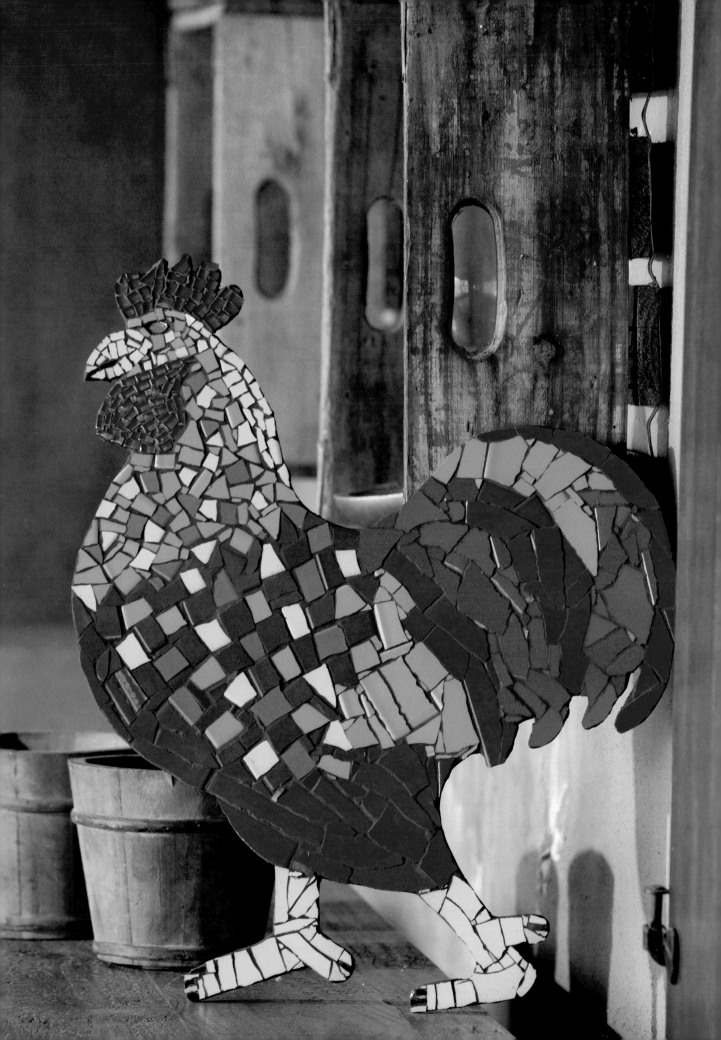

ALEXANDER'S ROOSTER

■■

We were wandering around our favourite discount home store, looking for something to mosaic when we came across this rooster (which was originally a plain blackboard). Well actually, Alexander, Tracy's 18-year-old son saw it and said he would do it for us. We were slightly sceptical because he'd never done mosaic before and all he had to work with was basically a plain black shape.

However, he is a bit of a perfectionist so that worked in his favour and besides that, we're firm believers in letting our kids get stuck into our crafts with us. And time was running out so we could do with all the help we could get!

YOU WILL NEED

Wooden rooster cut-out

Box of coloured chalk

Red glass tiles

Wheeled nippers

Toothpicks

Tile adhesive

Glazed red ceramic tiles

Glazed orange ceramic tiles

Glazed green ceramic tiles

Glazed mustard ceramic tiles

Glazed dark brown ceramic tiles

Glazed light brown ceramic tiles

Black glass tiles (off-cuts)

Small mirror off-cut

Palette knife

Charcoal black grout

Grout applicator

Firm sponge

Lint-free cloth

Use the chalk to roughly draw and colour in the details of the rooster, using a picture as a guide if you need to, and colouring in sections to match the colours of the tiles.

Cut similarly-sized rectangles from the glass tiles and glue them around the edges of (and in) the rooster's wattle. Use toothpicks to apply the adhesive. Now cut small pieces to fill in his crest.

Working with the ceramic tiles, begin at the beak and work down his body, increasing the size of the tile pieces as you make your way down to his chest. Once you get to the green section at the bottom of his body, cut longer and bigger strips. Use a palette knife to apply the adhesive to these bigger pieces.

When working on the tail, use large, irregular shapes combined with the odd tiny piece to fill in gaps. Use a combination of shapes and sizes when it comes to gluing down the mustard tiles for the feet. Cut really small pieces of the black glass tile for his claws and the inside of his beak and glue them down with the aid of a toothpick. Finish off by cutting an eye out of the mirror off-cut, glue it down and leave the rooster overnight to dry.

Mix the tile grout according to the manufacturer's instructions and apply using the applicator. Once you have finished grouting, leave it to dry for about an hour. Then take the sponge, dip it in water and squeeze it until it's almost dry. Wipe it gently over the top and edges of your work in order to smooth the grout and also wipe away the excess from the surface of the tiles. Keep cleaning the sponge as you work but ensure that you squeeze out as much water as possible each time you do so. Leave it overnight to dry and then buff with a lint-free cloth.

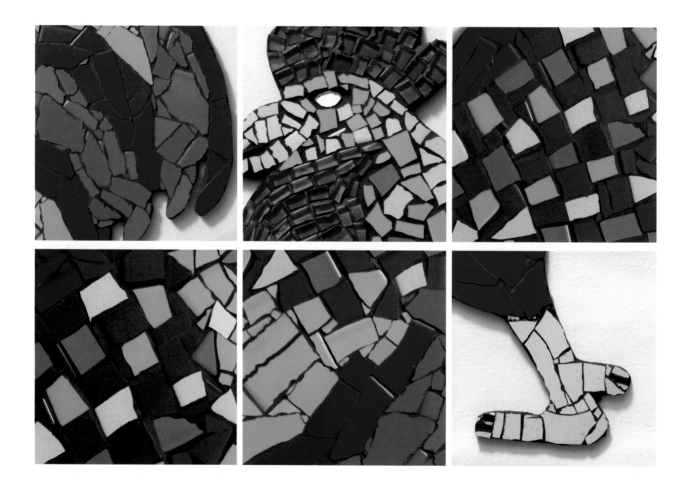

HANDY HINTS

- Alexander didn't allow himself to be restricted by tile size or technique and it worked out really well, so go ahead, break a few rules!
- Colouring in your pattern before you begin gluing can be really helpful because it gives you an idea of what it's going to look like at the end.

MIRROR WITH CIRCLES

■■

Mosaic work done with mirrors alone seems to have a striking, sparkly and fresh look, especially when you add either a circular or flowing pattern to it.

Mirror is pretty cheap to work with, even more so if you are prepared to cut the pieces yourself as many glass companies are prepared to give you their off-cuts for free or next to nothing.

We were lazy though and bought pre-cut mirror tiles from one of our local tile shops that's noticed the interest in mosaic work and is now cutting and packaging tiles virtually every day as this side of the business grows.

YOU WILL NEED

Piece of hardboard 53 cm x 62 cm

Ruler

Soft pencil

Mirror 28.5 cm x 37.5 cm

Clear mirror silicone

Toothpicks (to apply silicone)

Pre-cut mirror tiles 1.5 cm x 1.5 cm

Wheeled nipper

White grout

Waterproofing sealant

Old credit card

Firm sponge

Lint-free cloth

Use the ruler to draw two diagonal lines, reaching from each corner at the top of your hardboard to the opposite corner at the bottom (creating an X). Turn the glass over and apply a generous amount of silicone to the back of it. Turn it again, right side up, and lay it down in position on the hardboard, making sure that each corner of the mirror meets the diagonal lines. This method is used to ensure that the mirror is placed centrally. Press it down firmly.

Start the design at the top right hand side, about 10 cm down from the corner. Cut a mirror square into quarters and glue the four pieces opposite each other. Cut four smaller chips to fill in the gaps between the quarters and stick them down. You can begin working on your circles: use the pre-cut squares to make (and glue) a circle around the pieces that you have just glued down, repeat this process, working outwards and adding three more circles.

Now move to the top left-hand side – you are going to work on a quarter circle. Cut a mirror square into quarters and stick three of them down, filling in with smaller chips if you need to. Use the mirror squares to form a quarter-circle around the pieces that you have glued down, repeating the process and adding five more quarter-circles. Once you have done that, you should have a feel for the process, so will be able to complete the half-circle between the two that you have already done.

Turn the board around so that the decorated area is close to your body, and repeat the whole process (working from the top right-hand side) so that the full circles are diagonally opposite each other as are the quarter-circles. Using our picture as a guide to complete the sides and fill in the gaps, continue until you are satisfied with your design and everything is stuck down. Leave overnight to dry.

Mix the tile grout according to the manufacturer's instructions, replacing the water with water-proofing sealant, and apply it using the credit card. Once you have finished grouting, leave it to dry for about an hour. Then take the sponge, dip it in water and squeeze it until it's almost dry. Wipe it gently over the top and edges of your work in order to smooth the grout and also wipe away the excess from the surface

of the tiles. Keep cleaning the sponge as you work but ensure that you squeeze out as much water as possible each time you do so. The sealant makes it a little bit harder to clean up but it's worth it for its waterproofing properties. Leave overnight to dry and then buff with a lint-free cloth.

HANDY HINTS ■■■■■■■■■■■■■■■■■■■■■■■■■■■■■■■■■■■■■■

- ■ Be cautious when cutting mirror as it is extremely sharp. You should actually wear protective glasses or goggles for this.
- ■ If you get silicone on the mirror, don't try scraping it off with a sharp object as the mirror scratches easily. We have learned that the only way to remove silicone is by using silicone remover, which we had never seen until this year.
- ■ Use only clear mirror (or neutral curing) silicone on mirror because it's acid-free and won't 'de-silver' the mirror over time.

■■

MIRROR-CHIP CANDLE HOLDERS

When we bought these candle holders, we had a good idea of what we wanted to do with them but weren't too sure how we'd go about it without it taking way too much time. So we decided to experiment and were pretty impressed with the results because we got the look we wanted and it took hardly any time at all.

The light that reflects off the mirror once the candles are lit makes the holders look rich and expensive – not bad for something that cost very little to make.

YOU WILL NEED

Glass candle holders
Piece of hardboard
Mirror off-cuts
Thick cloth
Hammer
Silicone
Toothpicks
White grout
Grout applicator
Firm sponge
Lint-free cloth

Place the piece of hardboard on a firm surface, lay one of the mirror off-cuts face down on the board and cover with the cloth. Gently, but firmly, hit down on the cloth-covered mirror with the hammer. Keep moving the hammer while hitting down on the cloth to ensure that the mirror breaks into tiny pieces, lifting the cloth every now and again so you can check your progress. Carefully remove the cloth, trying not to disturb the glass pieces.

Squeeze out a blob of silicone and use the side of a toothpick to spread it over a small section of the candle holder. Now roll the holder over the pieces of mirror, adjusting the pieces slightly where necessary. Continue in this manner, breaking the mirror and rolling the holder over it until it is entirely covered. Leave overnight to dry.

Mix the tile grout according to the manufacturer's instructions and apply using the applicator. Once

you have finished grouting, leave it to dry for about an hour. Then take the sponge, dip it in water and squeeze it until it's almost dry. Wipe it gently over the top and edges of your work in order to smooth the grout and also wipe away the excess from the surface of the tiles. Keep cleaning the sponge as you work but ensure that you squeeze out as much water as possible each time you do so. Leave it overnight to dry and then buff with a lint-free cloth.

HANDY HINTS

- Be very careful when clearing away the shards of mirror from the hardboard because they are razor sharp.
- You will have to use your fingers to grout along the top of the candle holder in order to get a neat edge so, once again, be very careful and wear gloves if you can.
- This is a quick and easy project that makes a great gift.

MIRRORED GECKO

This little guy actually came together fairly quickly, which we found surprising because we thought the odd shape might make it a lot more time-consuming. If you're making something like this and it's going to hang outside, please remember to seal the wood (and the grout) to protect it from moisture.

We used pre-cut mirror tiles for the project, which could have had something to do with the speediness, though we did have to do a bit of cutting here and there. We combined squares with randomly shaped pieces to add subtle interest to the design.

YOU WILL NEED

Wooden gecko
Pre-cut square mirror tiles
Black glazed ceramic tile off-cuts
Pre-nipped mirror tiles
Soft pencil
Wheeled nippers
Silicone
Toothpicks
Charcoal grout
Old credit card
Firm sponge
Lint-free cloth
Black acrylic paint
Paintbrush
Medium-grit sandpaper

Start off with the square tiles, placing them down the centre of the body, from head to tail. When you are happy with their positioning, glue them down, using silicone and a toothpick. Now take the black ceramic off-cuts, draw the eye shapes on them with a pencil and use the wheeled nippers to 'nibble' around those lines. Once you are satisfied with the shape of the eyes, position and glue them down.

Empty your bag of pre-nipped tiles onto your work surface (or a tray) and spread them out so you've got a good selection of shapes with which to work. Look for slightly curved pieces to be used on the curves of the gecko's body. Work on a section at a time, laying the outer curved pieces first and working inwards. You will probably have to cut smaller bits occasionally to fill some of the gaps. Once you have finished, clean away excess silicone using a toothpick and leave overnight to dry.

Mix the tile grout according to the manufacturer's instructions and apply it, using the credit card. It's a

little bit tricky working around the outer edges, especially the legs, so we used our fingers as well as the credit card on those sections. Once you have finished grouting, leave it to dry slightly for about an hour. Then, take the sponge, dip it in water and squeeze it until it's almost dry. Wipe it gently over the top and edges of your work in order to smooth the grout and also wipe away the excess from the surface of the tiles. Keep cleaning the sponge as you work but ensure that you squeeze out as much water as possible each time you do so. Leave to dry and then buff with a lint-free cloth.

Gently sand the outer edges in order to remove any lumps of grout. You will probably have to sand underneath as well in order to get rid of bits of dried grout. Paint the bottom (and sides, if necessary) with black acrylic paint. If the wood feels slightly rough after the first coat, sand it lightly before applying subsequent coats. You will probably have to give it about 2 – 3 coats, allowing drying time between them.

HANDY HINTS

- Take care when cutting the bits of mirror. We like to put the piece to be cut into the 'jaws' of the nipper and, as we press the handles together, cup our other hand under and around the jaws in order to catch both pieces.
- We used a credit card for grouting because the sharp edges of some of the mirror tiles damage the rubber of the grout applicator.
- If you use your fingers around the edges, do so carefully to avoid lacerating yourself. Perhaps you should just wear gloves.
- If you have spread grout fairly evenly on the sides, you shouldn't have to paint them.

FISH AND BUBBLES MIRROR

It's 4.45 pm on Saturday afternoon and we are due to leave for Cape Town tomorrow morning for our photo shoot for this book. We still have to finish off a couple of items and wrap them in bubble wrap, make sure there's enough groceries in the cupboard for a week, try to explain to our husbands the children's routine and, as if that's not enough we haven't quite finished our writing. So, we would love to say something inspiring, clever and witty about this mirror but nothing even vaguely like that springs to mind.

We'll give it a bash though: This is a very nice mirror and we suggest you make one. Especially if you like fish. And mirrors.

YOU WILL NEED

Round wooden base
Waterproofing sealant
Paintbrush
Round mirror
Clear mirror silicone
Toothpicks
Tile adhesive
Palette knife
3 glazed ceramic fish
15 light blue glass pebbles
Mirror off-cuts
Wheeled nippers
Charcoal grout
Old credit card
Firm sponge
Lint-free cloth

This mirror was made especially for a bathroom so we painted a coat of waterproofing sealant onto the wooden base (both sides and edges) to give it added protection. When dry, glue the mirror into the centre of the board, using silicone. Now using tile adhesive, stick the fish around the mirror, allowing equal spacing between them.

Go back to using silicone in order to glue the glass pebbles down, using a small blob applied to the pebble with a toothpick. Put five pebbles (or in this case, bubbles) between each of the fish.

Take the mirror off-cuts and use the wheeled nippers to cut pieces for the outer border – ensuring that the pieces are approximately the same size. Glue them in place with the silicone, working until the border is complete. Now cut similarly shaped pieces, only smaller this time, and glue them down alongside the outer border (you

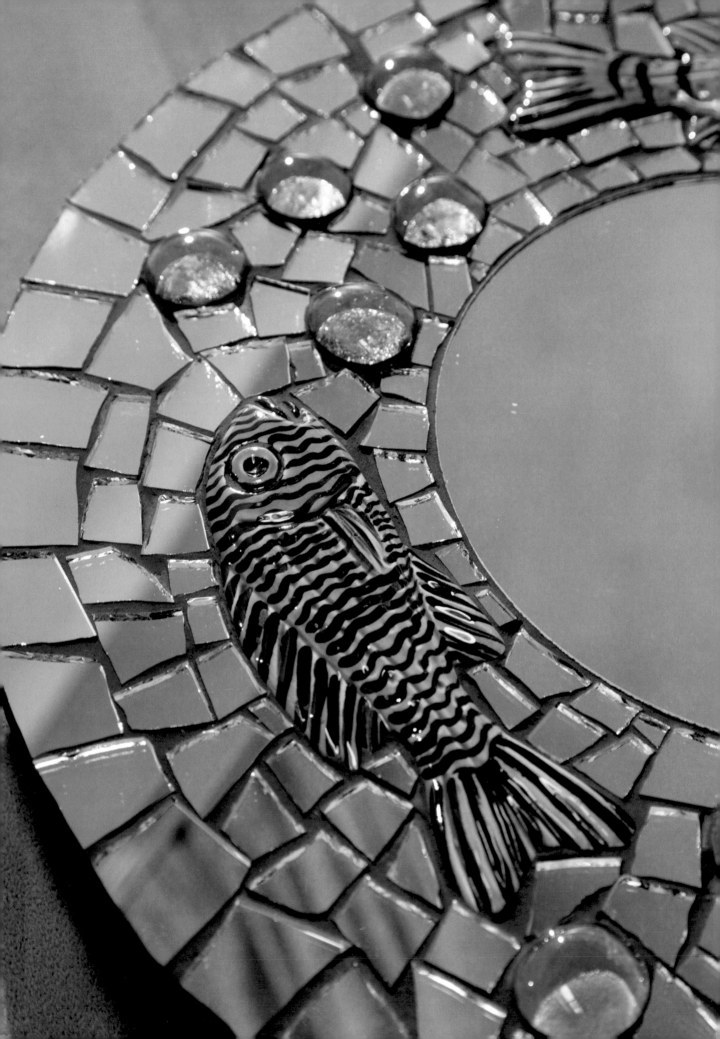

are moving towards the central mirror). Continue in this fashion, making each row a little smaller than the last one, until you get to the central mirror.

Mix the tile grout according to the manufacturer's instructions, replacing the water with water-proofing sealant, and apply it using the credit card. Once you have finished grouting, leave it to dry for about an hour. Then take the sponge, dip it in water and squeeze it until it's almost dry. Wipe it gently over the top and edges of your work in order to smooth the grout and also wipe away the excess from the surface of the tiles. Keep cleaning the sponge as you work but ensure that you squeeze out as much water as possible each time you do so. The sealant makes it a little bit harder to clean up but it's worth it for its waterproofing properties. Leave overnight to dry and then buff with a lint-free cloth.

HANDY HINTS

- Use your fingers when applying grout around the pebbles but be careful not to cut them on the sharp mirror edges.
- Extend the grout over the edge and around the sides of the base to complete it.
- You should actually wear goggles and rubber gloves when working with glass.

DECORATIVE WORDING

If this doesn't remind you of scrapbooking, then you obviously haven't got involved in the craft or even looked at an album because quite frankly, my dear, this simply screams scrapbooking! All that's missing here is the dictionary definition of the word.

We enjoyed working with words because it's slightly different from everything else that we've done. And it's amazing how many people wanted to buy them from us because they are different, which means they would make great gifts. We made two of them but will only give you specific instructions for the white one in order to both prevent repetition and make it clearer for you. The same rules apply to both words though.

YOU WILL NEED

Wooden word
Glazed ceramic embellishments
Soft pencil
Glazed white ceramic tiles
Pre-nipped mirror tiles
Side biters
Sharpening stone (optional)
Tile adhesive
Palette knife
White grout
Grout applicator
Firm sponge
Lint-free cloth
White acrylic paint
Paintbrush

Fiddle around with the placement of the embellishments, and once you have decided where you would like to put them, hold them in position and draw around them with the pencil. Put them aside to be attached later.

Use the side biters to cut the tiles but don't try to stick to a particular shape or size (within reason, of course – you don't want a piece that's 5 times bigger than the rest of them). Once you have cut up about half a tile, you can begin to place and glue the pieces down

using the adhesive. You'll probably have to do a little nipping here and there to ensure a good fit. When working with your tile pieces, look out for natural curves and use them on rounded letters, corner tile pieces are ideal for letters that have ninety-degree angles, and the straight edge pieces should be kept for the straight edges of the letters.

When you get to an 'embellishment area' that has been marked with the pencil, work around it, ensuring that you leave a little extra

space around the embellishment for grouting. As you work, put in the odd mirror tile to add interest to your work. If you find that some of the edges of the tiles are a bit sharp or you need to curve them a little, use the sharpening stone to blunt or shape them. When you have completed gluing the tile pieces down, leave overnight to dry.

Mix the tile grout according to the manufacturer's instructions, and apply it using the applicator. Once you have finished grouting, leave

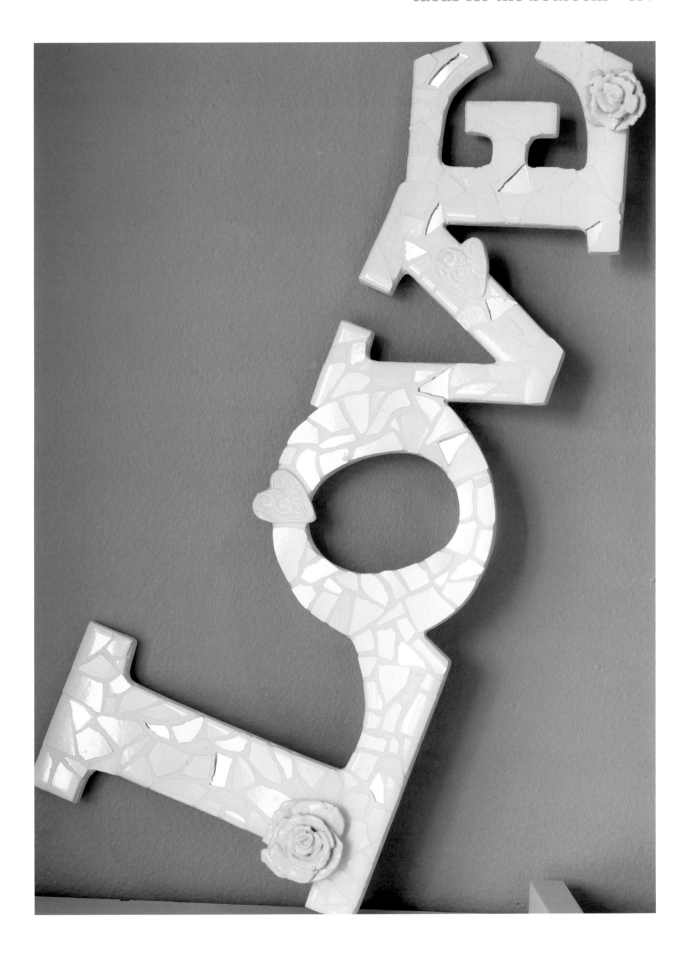

it to dry for about an hour. Then take the sponge, dip it in water and squeeze it until it's almost dry. Wipe it gently over the top and edges of your work in order to smooth the grout and also wipe away the excess from the surface of the tiles. Keep cleaning the sponge as you work but ensure that you squeeze out as much water as possible each time you do so. Leave overnight to dry.

Now it's time to put in the embellishments: glue them firmly down and leave them to dry. Mix up a small amount of grout and work it around the embellishments, using a palette knife and your fingers where necessary. Leave for about an hour, smooth the area with a damp sponge and, when dry, buff with a lint-free cloth.

Paint the edges with white acrylic paint. If it feels slightly rough after the first coat, sand it lightly before applying subsequent coats. You will probably have to give it a couple more coats, allowing drying time between them.

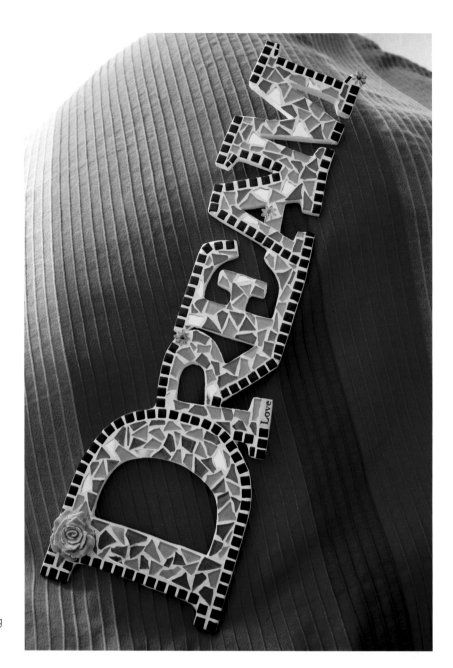

HANDY HINTS

■ It's often better to paint the word with waterproofing sealant before beginning to mosaic – it stops the word from curving slightly if too much moisture gets into the wood.

■ We add the embellishments afterwards because it's easier to clean excess grout neatly off the tiles if there aren't raised areas to contend with – in this instance the hearts wouldn't create as much of a problem as the roses.

GOTHIC CROSS

■■■

No, we aren't 'Goths' and neither is Natasha, who did this for us. It just ended up looking a little, um, Gothic, especially once she added the crystal, which matched the tiles perfectly. As it is rather striking, we decided to include it in the book because crosses are currently very popular in mosaic work. If you're not crazy about dark crosses, you can use exactly the same idea but simply change the colours to, say, white and cream and you'll get a completely different look. The interesting thing about Natasha's work is that she does it twice as quickly as we do, probably because she's a novice and doesn't feel bound by any 'mosaic rules'. In fact, come to think of it, much the same could be said about her driving, unfortunately. Anyway … there's probably a lesson in there somewhere.

YOU WILL NEED

Wooden cross
Soft pencil
Black glazed ceramic tiles
Purple glazed ceramic tiles
Wheeled nippers
Tile adhesive
Palette knife
Toothpicks
Pre-cut square mirror tiles
Pre-nipped mirror tiles
Crystal/stone/embellishment
Charcoal grout
Old credit card
Firm sponge
Lint-free cloth
Black acrylic paint
Paintbrush
Medium-grit sandpaper

Draw your design onto the cross, using the pencil. Write down which colours go into the various sections because sometimes you can get a bit carried away while you're cutting and sticking, and you can lose sight of what goes where. Use the wheeled nippers to cut the black tiles into random shapes and sizes and begin sticking the pieces down, reshaping when necessary to make them fit.

Once you have finished with the black tiles, move on to the purple ones, remembering to leave space for the mirror tiles. Ensure that you remove any excess grout from between the tiles and use tweezers and a toothpick to put the small tile pieces in position.

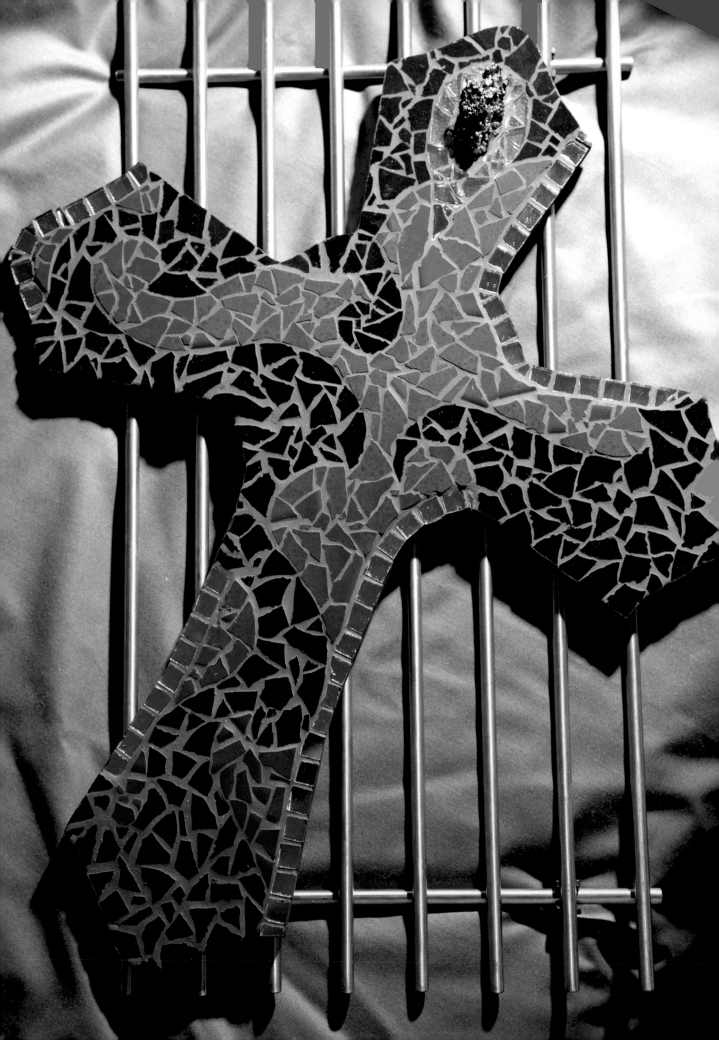

Now glue down the square mirror tiles, using the wheeled nippers to 'nibble away' at the tiles where you need to shape them. The pre-nipped mirror tiles were used on the section at the top of the cross (it looks like an upside-down droplet) and also had to be cut down here and there to complete the pattern.

Mix the tile grout according to the manufacturer's instructions and apply it, using the credit card. Keep the section where you are going to place your embellishment free of grout. Once you have finished grouting, leave it to dry for about an hour. Then take the sponge, dip it in water and squeeze it until it's almost dry. Wipe it gently over the top and edges of your work in order to smooth the grout and also wipe away the excess from the surface of the tiles. Keep rinsing the sponge in the water as you work but ensure that you squeeze out as much water as possible each time you do so. Leave it to dry and then buff with a lint-free cloth.

Now stick the embellishment down using tile adhesive, leave it to dry overnight and then mix up a little grout, press it in around the embellishment, using the credit card or your fingers (or both) and then repeat the aforementioned sponging step.

Paint the edges and back of the cross with black acrylic paint. If the edges feels slightly rough after the first coat, sand it lightly before applying subsequent coats. You will probably have to give it about 2 – 3 coats, allowing drying time between them.

HANDY HINTS

- Natasha didn't know about using a sharpening stone to blunt the edges of sharp tile pieces, so we used the stone on the outer edges of the cross once it was glued firmly down. Keep 'filing' in one direction, rather than up and down, which could damage the tiles. It's always better to do it before sticking pieces down though.
- When working with really small pieces, it's best to apply a small amount of adhesive directly onto your base (using a toothpick) and put the tile piece in position with a pair of tweezers.

GEMSTONE HEART

This wooden heart was sitting on the top shelf of a bookcase, gathering dust. In fact, we probably would have forgotten about it had we not noticed decorated hearts popping up in magazines and home décor shops. So we got it down, dusted it off and went shopping!

After getting slightly distracted by the Woolies sale (who wouldn't?), we made our way to a local curio shop where we found these lovely gemstones. The metal heart comes from a mosaic shop and – we hate to admit this – the other silver embellishments were once part of a necklace, until we decided they would look better on our heart.

YOU WILL NEED

Wooden heart
Large metal heart embellishment
Tile adhesive
Palette knife
Small, square metal tiles
Toothpicks
Soft pencil
Glazed grey ceramic tile
Side biters
Heart and leaf metal embellishments
White Howlite gemstones
Dove grey grout
Firm sponge
Lint-free cloth

Apply a generous amount of tile adhesive to the back of the metal heart and glue it down on the wooden heart. Now glue the small metal tiles around it so that they form a border. Remove any excess adhesive with a toothpick.

Write the word LOVE in pencil underneath the metal heart, cut the grey tile into small rectangles, and glue them down over the word.

Glue the heart and leaf embellishments on either side of the central heart and add the metal tiles. Use a toothpick to apply a little adhesive to the back of a gemstone and press it down to glue it, repeating until you have covered the heart in stones. Leave overnight to dry.

Mix the tile grout according to the manufacturer's instructions and apply it using a palette knife and your fingers. Once you have finished grouting, leave it to dry for about an hour. Then take the sponge, dip it in water and squeeze it until it's almost dry. Wipe it gently over the top and edges of your work in order to smooth the grout and also wipe away the excess. Keep cleaning the sponge as you work but ensure that you squeeze out as much water as possible each time you do so. Leave overnight to dry and then buff with a lint-free cloth.

HANDY HINTS

- It's impossible to grout with a credit card or applicator because the stones are irregular – use a palette knife to apply a blob of grout and then spread it with your fingers.
- Teenage and pre-teen girls seem to really love this heart. Either buy them the materials to make it themselves or make it for them for a special occasion.

SOPHIE NAMEPLATE

■■

This is a quick-and-easy project and because we wanted to put the embellishments on top of the tiles, it meant that we could fiddle around with choices and their placement once we had finished grouting and polishing.

The only problem we encountered with this one came from the subject herself. She saw us making it and said, 'I hope you're not thinking of putting that on my door'. We were going to explain that she is the only Sophie living in the house but decided to avoid confrontation; after all, she is a teenager and we're just old people who know nothing. Strangely enough, her friends thought it was really 'cool' but we guess that if their mom made it, they'd also hate it!

YOU WILL NEED

Wooden nameplate

Wooden lettering

White acrylic paint

Black acrylic paint

Paintbrush

Medium-grit sandpaper

Small black glass tiles

Pre-cut mirror pieces

Toothpicks

Dark grey grout

Grout applicator

Firm sponge

Lint-free cloth

Embellishments

Paint the edges of the nameplate with black acrylic paint. If the wood feels slightly rough after the first coat, sand it lightly before applying subsequent coats. You will probably have to give it at least 2 – 3 coats, allowing drying time between coats. Repeat this process with the white paint and lettering.

Lay the letters and tiles down to get an idea of the spacing. When you are satisfied, glue the letters down using a toothpick to apply the adhesive. Now begin gluing down the black tiles. It isn't necessary to remove them from the netting first, rather cut sections of tiles (attached to the netting) to stick down. That way you automatically get even spacing and you are finished gluing in no time. Stick the mirror tiles and single black tile and leave overnight to dry.

Mix the tile grout according to the manufacturer's instructions and apply using the applicator. Once you have finished grouting, leave it to dry for about an hour. Then take the sponge, dip it in water and squeeze it until it's almost dry. Wipe it gently over the top and edges of your work in order to smooth the grout and also wipe away the excess from the surface of the tiles. Keep cleaning the sponge as you work but ensure that you squeeze out as much water as possible each time you do so. Leave it overnight to dry and then buff with a lint-free cloth.

Play around with various embellishments until you are happy with their placement. Glue them down with adhesive, taking care to clean up any excess with a toothpick. Leave to dry.

HANDY HINTS

- Don't try and cut a section out of the netted tiles (for the lettering) and then stick the rest of them down in one go – you don't have enough control over it and it becomes difficult to keep the lines straight. Rather work with smaller sections at a time.
- You'll probably have to give the letters another coat of paint by the time you have finished cleaning the grout because the process removes a bit of the paint and also colours them slightly. If you like a weathered look, you won't need to repaint.

FLORAL COAT THINGY

When it came to writing about this project, we spent a lot of time trying to work out what to call it, so we brought in a jury of five. This resulted in a hung jury because none of us could agree but at the same time we couldn't really disagree either. So we're leaving it up to you to decide …

We wanted to use a basic, but effective pattern for the background of this coat thingy but it would have been difficult to keep it flowing if we inserted the flowers, so we decided to rather put them over the grouted tiles. This actually worked out quite well because we were toying with the idea of creating a 'dimensional mosaic' anyway.

YOU WILL NEED

Wooden coat thingy
Black acrylic paint
Paintbrush
Medium-grit sandpaper (optional)
Glazed cream ceramic tiles
Side biters
Tile adhesive
Palette knife
Cream grout
Grout applicator
Firm sponge
Lint-free cloth
Glazed ceramic flower embellishments

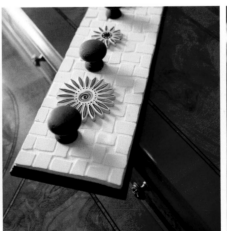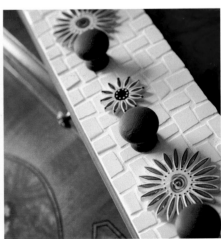

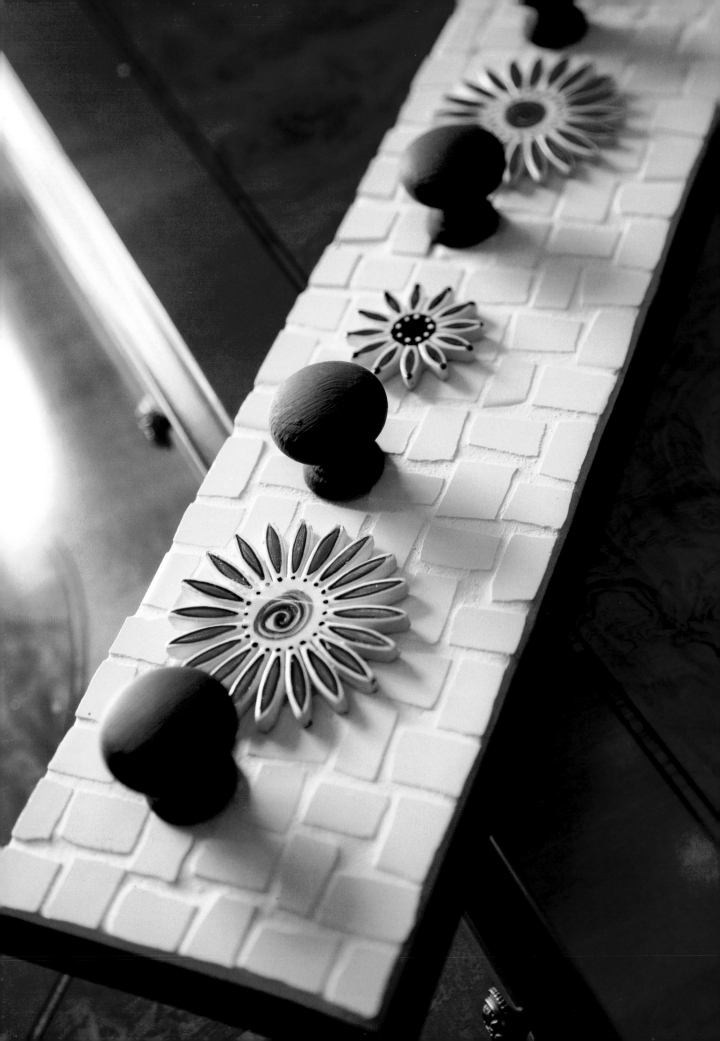

Remove the wooden knobs and paint them and the edges of the blackboard with acrylic paint. If the wood feels slightly rough after the first coat, sand it lightly before applying subsequent coats. You will probably have to give it at least 2 – 3 coats, allowing drying time between coats. Set the knobs aside, you will only put them on once you have finished grouting and polishing.

Use the side biters to cut the cream tiles into short rectangles and glue them down, starting at one corner and working lengthwise. Place one vertically and the next one horizontally, continuing until you have completed the row. Now repeat the process (starting with a horizontally placed tile though) on the next row, and so on until you have finished. Leave overnight to dry.

Mix the tile grout according to the manufacturer's instructions and apply using the applicator. Once you have finished grouting, leave it to dry for about an hour. Then take the sponge, dip it in water and squeeze it until it's almost dry. Wipe it gently over the top and edges of your work in order to smooth the grout and also wipe away the excess from the surface of the tiles. Keep cleaning the sponge as you work but ensure that you squeeze out as much water as possible each time you do so. Leave it overnight to dry and then buff with a lint-free cloth.

Put the knobs back on and, using a fair amount of adhesive – within reason, of course – stick the flower embellishments down, pressing them firmly into place.

HANDY HINTS

- Use a sharpening stone to blunt the edges of any of the tile pieces that are a little too sharp, especially if they are on the outer edges of the thingy.
- If you've applied a little too much adhesive to the embellishments, it will squeeze out and up from beneath the tiles – use a toothpick to remove this excess.
- This is more of a PS: once we had finished writing about this, we turned it over when putting it away and noticed the label on the back – Towel hanger. We prefer thingy though …

WORDED PHOTO FRAME

■■■

We bought these words specifically to use in a photo frame – probably the scrappers in us coming out because this does look very much like the beginnings of a scrapbook page.

We kept the mosaic work very simple because we didn't want it to overpower the wording or the photograph.

YOU WILL NEED

Wooden photo frame

4 glazed ceramic word tiles

Tile adhesive

Palette knife

Red glass tiles

Grey glass tiles

Dove grey grout

Grout applicator

Firm sponge

Lint-free cloth

Use the tile adhesive to glue two of the worded tiles opposite each other on the outer edges of the frame. Now do the same thing with the remaining two tiles, this time gluing them to the inner edges.

Begin gluing a row of glass tiles, starting at the outer edges and alternating between the red and grey. Once this is done, complete the frame by adding another two rows, working inwards. Leave over-night to dry.

Mix the tile grout according to the manufacturer's instructions and ap-ply using the applicator. Take the grout over the edges of the frame, then you won't have to paint them. Once you have finished grouting, leave it to dry for about an hour. Now take the sponge, dip it in water and squeeze it until it's almost dry. Wipe it gently over the top and edges of your work in order to smooth the grout and also wipe away the excess from the surface of the tiles. Keep cleaning the sponge as you work but ensure that you squeeze out as much wa-ter as possible each time you do so. Leave it overnight to dry and then buff with a lint-free cloth.

HANDY HINTS ■■■■■■■■■■■■■■■■■■■■■■■■■■■■■■■

- Lay the tiles (decorative and glass) on the frame before you begin gluing to get an idea of spacing. Our frame was a little bit too small so we allowed the tiles to overlap the inner frame edges. As the tiles come on net-ting, we left that in place so that the grout had something on which to adhere.
- If your decorative tiles are slightly higher than the glass ones (like ours are), use your fingers to work the grout around them.
- We like to work with strips of tiles, keeping them attached to the netting if we can because it gives us auto-matic spacing. Ensure that you cut the netting close to the sides of the tiles though, otherwise you could end up with plastic bits sticking out from the edges of your work.

■■■

NEWSPAPER STATIONERY SET

■■■

This is one of those projects where we wanted to find something that worked with the tiles, rather than the other way round. In fact, we only had one tile with lettering on it, so we had to choose our base (in this case, bases) carefully, ensuring that it wasn't too big. We also had to be really careful when cutting the tile because it was the only one. In fact, it was such a tense moment that we considered having a gin and tonic to calm our nerves and get into the zone but decided that no tile was going to get the better of us, and turned instead to our secret weapon - the score-and-snap cutters!

YOU WILL NEED

Wooden stationery set

1 decorative glazed ceramic tile

1 plain glazed ceramic tile

Soft pencil

Ruler

Score-and-snap cutter

Tile adhesive

Palette knife

Toothpicks

Light grey grout

Grout applicator

Firm sponge

Lint-free cloth

Grey acrylic paint

2 paintbrushes

Medium-grit sandpaper (optional)

White acrylic paint

Use the ruler and pencil to measure and mark the opposite sides of the tile. Our width measurement for the decorative tile strip is 15 mm, but the plain one has both 15 mm and 10 mm widths, so rather mark and cut those strips as you need them. Using your pencil marks as a guide, score the tile from one side to the other. We did it freehand but you may prefer to use a ruler. Now cut the tile using the 'snapping' part of the tool to produce a strip. Continue in this way until you have cut the whole tile.

Work out how you are going to place the decorative tile pieces before cutting the strips into smaller sections. We started with the section that says 'The New York Times' and worked around it. If your tile has a definite pattern, cut up one strip at a time, and glue the pieces next to each other so that you keep the pattern. You probably won't be able to keep the pattern flow on all four sides but it should work on the front and sides, which are the most important.

Once you have glued down the decorative tile pieces, work out what width you need for the plain tiles and cut the strips accordingly. Now cut these into slightly smaller pieces than the ones you cut out of the decorative tile (because you don't want the gaps to line up with each other) and stick them down. Remove excess grout with toothpicks and leave overnight to dry.

Mix the tile grout according to the manufacturer's instructions and apply it using the grout applicator. Once you have finished grouting, leave it to dry slightly for about an hour. Then, take the sponge, dip it in water and squeeze it until it's almost dry. Wipe it gently over the top and edges of your work in order to smooth the grout and also wipe away the excess from the surface of the tiles. Keep cleaning the sponge as you work but ensure that you squeeze out as much water as possible each time you do so. Leave to dry and then buff with a lint-free cloth.

Paint the items with grey acrylic paint, taking it over the top edge of the tiles to give it a neat finish. If the wood feels slightly rough after the first coat, sand it lightly before applying subsequent coats. You will probably have to give it about 2 – 3 coats, allowing drying time between them. When it is completely dry, mix up a white wash – 1 teaspoon white acrylic paint to 1 teaspoon of water. Use a clean, dry paintbrush to apply the white wash over the grey, continuously brushing to avoid runs and give it a slightly streaky look. If you want it lighter, apply a second coat once the first one is dry. Leave to dry and remove any excess paint from the face of the tiles.

HANDY HINTS

- Don't bother putting tiles on the back of the business card holder. It looks better without them and you may not have enough anyway!
- Do bother putting them on the back of the paper holder (or whatever it's called) as it just won't look right without them.
- When placing the tile pieces down, work from the outer edges inwards, towards the centre, adjusting the size of the middle piece if necessary.

CHESSBOARD

■■

We've found that when you have one of those light bulb moments, it's best to act on them immediately otherwise you can put it off for so long that it never gets done – or you forget the fabulous idea altogether!

The inspiration for this project came from the tiles themselves as they were displayed together for sales purposes. The minute we saw the tiles in the shop, the idea of a chessboard sprung to mind so we hunted around for 'a little something else', found the grey, black and white strip tiles and eagerly rushed home to get started.

YOU WILL NEED

Hardboard

32 white tiles

32 black tiles

Ruler

Pencil

Tile adhesive

Palette knife

Decorative strip tiles

Small black glass tiles

Small white glass tiles

Dove grey grout

Grout applicator

Firm sponge

Lint-free cloth

In order to sort out what size hardboard you need, place eight tiles next to each other and add 6 cm to that measurement. If, for example, the total is 86 cm, then you need hardboard cut 86 cm x 86 cm. If you are great with an electric saw, go ahead and do it yourself. We like to keep all of our fingers though, so prefer to ask Christopher or the lovely chap at the hardware store to do it for us.

Once you have the board, measure in 3 cm from all sides and draw lines from one end to the other – the middle section is the playing area and the outer edges make up the border. Glue down your first row of tiles, alternating black and white and placing them very close to each other. Move onto the next row, starting with a different coloured tile to the one above it. Continue in this way until you have completed eight rows in total.

The strip tiles came attached to netting and arranged as you see them. They are a lot thinner than the chessboard tiles but we had a plan … Cut the strips into 3 cm widths and glue them alongside the black and white tiles to form a border around all sides of the chessboard. Allow to dry.

Now glue small black glass tiles around each corner of the board (on top of the strip tiles to raise them to the level of the larger tiles), then glue another strip in the middle of each side. Finish off by filling in the rest of the space with small white glass tiles. Leave overnight to dry.

Mix the tile grout according to the manufacturer's instructions and apply using the applicator. Once you have finished grouting, leave it to dry for about an hour. Then take the sponge, dip it in water and squeeze it until it's almost dry. Wipe it gently over the top and edges of your work in order to

smooth the grout and also wipe away the excess from the surface of the tiles. Keep cleaning the sponge as you work but ensure that you squeeze out as much water as possible each time you do so. Leave it overnight to dry and then buff with a lint-free cloth.

HANDY HINTS

- Lindie, our very helpful book designer, had a great tip for us: "If you are a backgammon player, don't make a chessboard." Thanks, Lindie, we would never have come up with such a brilliant handy hint.
- If you can't find the right colour chess pieces for your board, you could always spraypaint wooden ones, as we did.
- We used traditional black and white for our chessboard but why not break from tradition and use two different colours – perhaps to suit the colour of your décor?

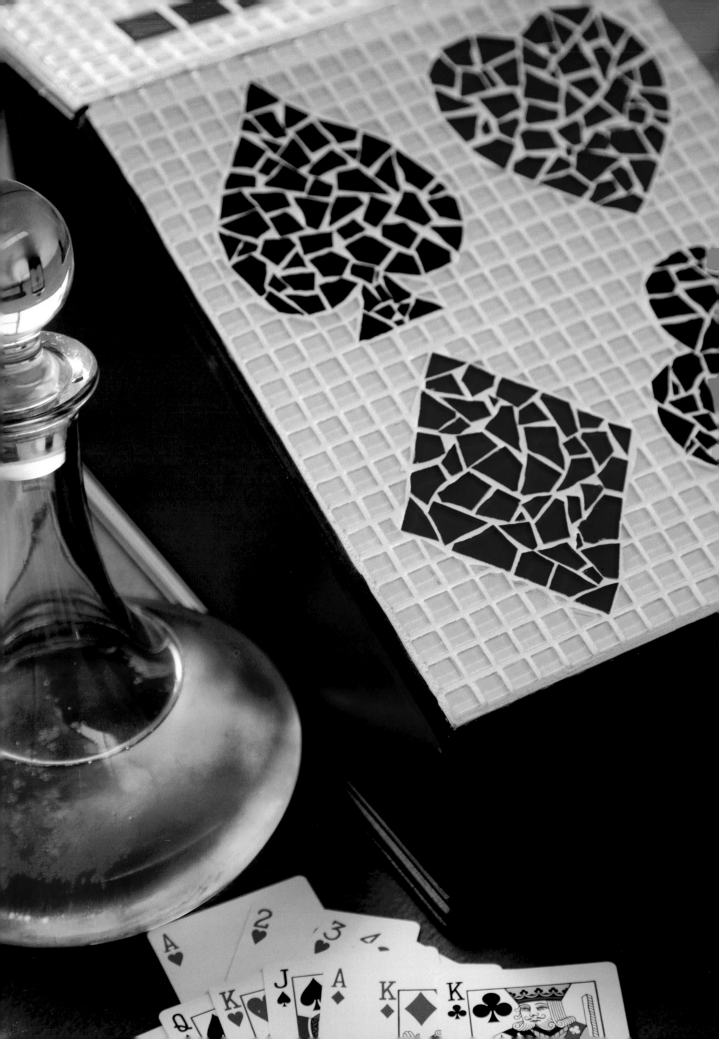

CARD BOX

■■

Another of our previously decoupaged items hits the dust! Tracy
had been using this box for her bridge paraphernalia so, in our quest
to save money and produce useful items, we decided to decorate it
according to its use …

We had to sand it down a bit to prepare it. It's not necessary to sand
furiously, trying to get down to the wood and putting your shoulder
out in the process. You just need to take the shine off and key it so
that paint and tiles adhere to it.

YOU WILL NEED

Wooden box

Black acrylic paint

Paintbrush

Medium-grit sandpaper (optional)

Soft pencil

Black glass tiles

Red glass tiles

Wheeled nippers

Tile adhesive

Toothpicks

Ruler

Small white glass tiles

White grout

Old credit card

Firm sponge

Lint-free cloth

Paint the outside, inside and lid of
the box using the acrylic paint. If
the wood feels slightly rough after
the first coat, sand it lightly before
applying subsequent coats. You
will probably have to give them at
least 2 – 3 coats, allowing drying
time between coats.

Draw the card images onto the
box. If you are not comfortable
drawing them freehand, print im-
ages from the internet, cut them
out and trace around them. Use
the wheeled nippers to cut black
and red tiles into various shapes of
approximately the same size. Cut
enough of each colour to give you
a selection of shapes with which
to work.

Begin with one image at a time,
working around the outer area
to form a border and reshap-
ing pieces as you need to. Stick
them down using tile adhesive
applied with a toothpick. Once
the border is done, fill in the
middle, working very much
like you would do with a puz-
zle (except here you are allowed
to cut pieces to fit). Complete
all four images in this way.

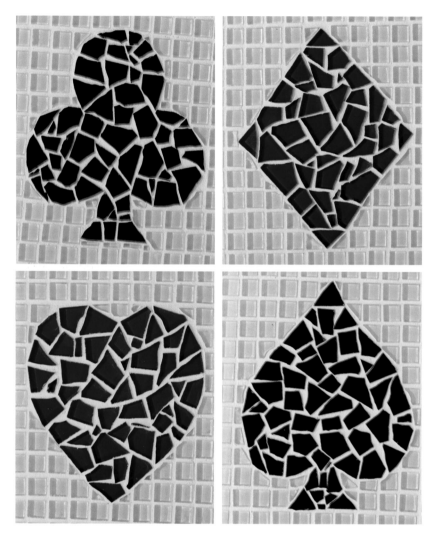

Measure and glue down a row of seven red glass tiles evenly on the top of the box. Fill in the background with rows of small white tiles, cutting some of them down as you get closer to the images in order to make them fit. Leave overnight to dry.

Mix the tile grout according to the manufacturer's instructions and apply using the applicator. Once you have finished grouting, leave it to dry for about an hour. Then take the sponge, dip it in water and squeeze it until it's almost dry. Wipe it gently over the top and edges of your work in order to smooth the grout and also wipe away the excess from the surface of the tiles. Keep cleaning the sponge as you work but ensure that you squeeze out as much water as possible each time you do so. Leave it overnight to dry and then buff with a lint-free cloth.

HANDY HINTS

- The white tiles are attached to netting which is very handy when it comes to keeping the spaces between tiles even, so wherever you can, try to keep sections of tile attached to the netting when gluing them down.
- Glass tiles can produce very sharp pieces after being cut so handle them with care and try to wear goggles, even if people (your husband and kids) laugh at you.

FLORAL PLANTER

■■■

This entire project (apart from the border tiles) was made using broken plates. This time we didn't upset anyone because the plates really were chipped and damaged. So if you have lovely old china that is so damaged it needs to be thrown away, rather preserve the past by using it for mosaic work than getting rid of it altogether. When it comes to breaking plates, you normally get two kinds of people: those who love it and smash the plate to smithereens and those who turn their heads and wince the minute they half-heartedly hit the plate. Your aim is to be somewhere in the middle.

YOU WILL NEED

Ceramic vase

3 floral china dinner plates

2 terry cloths

Hammer

2 boards (optional)

Wheeled nippers

Tile adhesive

Palette knife

Pre-cut light blue ceramic tiles

Pre-cut mustard ceramic tiles

Oatmeal grout

Grout applicator

Firm sponge

Lint-free cloth

BREAKING PLATES: Place a terry cloth on a hard surface and put the plate (upside down) on top of it, covering it with a second cloth. Feel for the ridge of the plate and, using the hammer, hit around this ridge in order to break the plate into manageable pieces. Lift up the towel every now and again to see how you are progressing; you should be left with fairly large pieces. Decide where you would

like the rest of your breaks, re-cover with the cloth and continue gently hitting (and checking) until you've got the sizes you want.

Before you start gluing you may want to turn the pieces over; in fact we found that it's a lot easier to work with the decorative pieces facing you. In order to do this, you need to 'sandwich' both the cloths and their contents between two

boards, slipping one board under the bottom cloth and another on top, hold them firmly and then flip the whole lot over.

Once you've uncovered the pieces, you can begin gluing. Take the inner floral design of one of the plates and begin gluing in place on the side of the vase – it's very much like doing a puzzle with small spaces between the pieces.

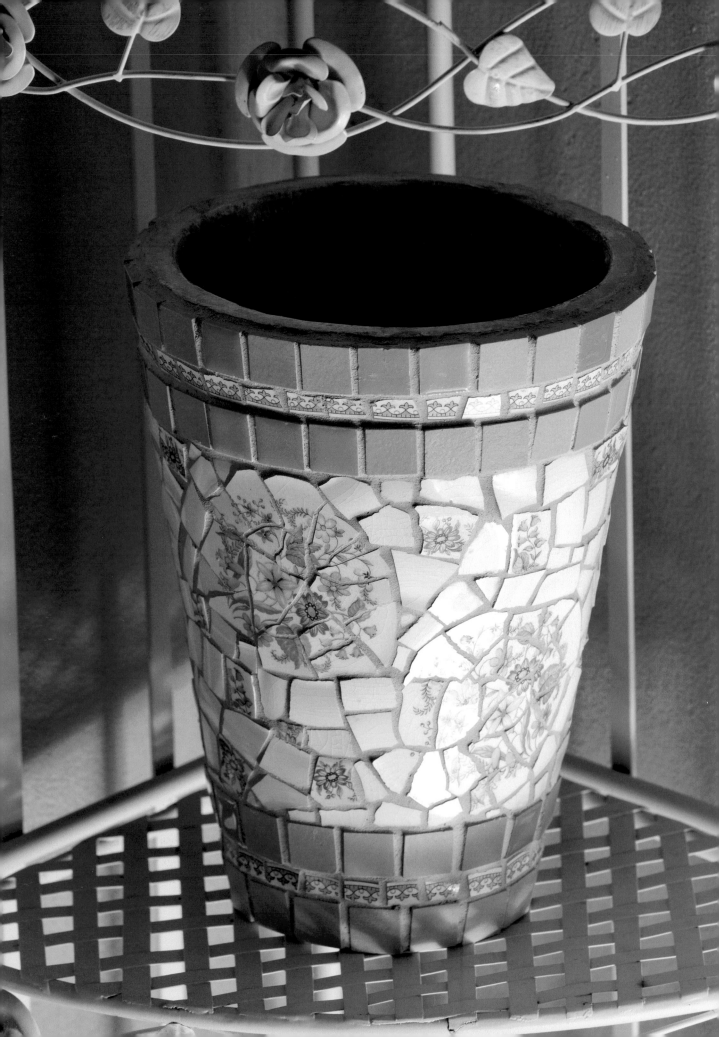

Ensure that the image lines up properly as you are gluing the pieces down. Put the rest of the plate pieces aside to be used later. Repeat this with the other two plates so that you have three designs glued onto the vase.

Glue a border of blue tiles around the top of the vase. Then use the border from the plates – cut into small rectangular pieces using the glass nippers – to form a row underneath the blue tiles. Finish off with a row of mustard tiles before turning the vase upside down and repeating the pattern on the base. Once done, fill in the rest of the vase with the plain china, cutting it to fit where necessary.

Mix the tile grout according to the manufacturer's instructions and apply it, using the applicator. Once you have finished grouting, leave it to dry for about an hour. Then take the sponge, dip it in water and squeeze it until it's almost dry. Wipe it gently over the top and edges of your work in order to smooth the grout and also wipe away the excess from the surface of the tiles. Keep cleaning the sponge as you work but ensure that you squeeze out as much water as possible each time you do so. Leave it overnight to dry and then buff with a lint-free cloth.

HANDY HINTS

- Break one plate and stick the picture down before breaking the next one. If you break them all beforehand it could get a little confusing.
- As the plates are curved, you will have to use your nippers to cut off any pieces that are too raised to use.
- If you find that you need to use your hand as well as the grout applicator to apply the grout (because of the curve of the vase), be careful of sharp edges. It would be a good idea to wear rubber gloves.
- Replace water with waterproofing sealant if the planter is going to be kept outdoors.

CHAMELEON PLANTER

We were really lucky to find a good, accommodating potter who helped us with all sorts of requests. Luckily, his wife has a mosaic studio so he's quite used to people asking for half-glazed items! In this case we wanted a bisque planter that was glazed on the inside for protection. The glazed embellishments and tiles also came from the same potter, which meant that we could get tiles as thick as the embellishments, which makes grouting a whole lot easier.

YOU WILL NEED

Planter
Glazed ceramic embellishments
Tile adhesive
Toothpicks
Palette knife
Cream glazed ceramic tiles
Green glazed ceramic tiles
Side biters
Oatmeal grout
Grout applicator
Firm sponge
Lint-free cloth

Use a generous amount of tile adhesive to glue the various embellishments in place and clean away any excess adhesive that squeezes up their sides using toothpicks.

Cut fairly thin, rectangular shapes from the green tiles (using the side biters) and glue them down all four edges of the planter. Now cut fairly large, irregular shapes from the cream tiles, trying to keep them approximately the same size. In order to keep a neat edge on the top of the planter, only use pieces of tile with straight, glazed edges for the top.

Once you have done this, complete the background by filling in with cream tile pieces. You will have to cut slightly smaller shapes to fit around the images. When finished, glue the other embellishments around the base of the planter – as it was glazed, we didn't need to mosaic around them.

Mix the tile grout according to the manufacturer's instructions and apply using the applicator.

Once you have finished grouting, leave it to dry for about an hour. Then take the sponge, dip it in water and squeeze it until it's almost dry. Wipe it gently over the top and edges of your work in order to smooth the grout and also wipe away the excess from the surface of the tiles. Keep cleaning the sponge as you work but ensure that you squeeze out as much water as possible each time you do so. Leave it overnight to dry and then buff with a lint-free cloth.

HANDY HINTS

- It's easier to use your fingers to apply the grout around the embellishments than working with an applicator.
- If you find that some of your tile pieces are a little too jagged, use a sharpening stone on the rough edges.
- We asked for the base to be glazed because we felt that mosaic and decoration would make it too busy.

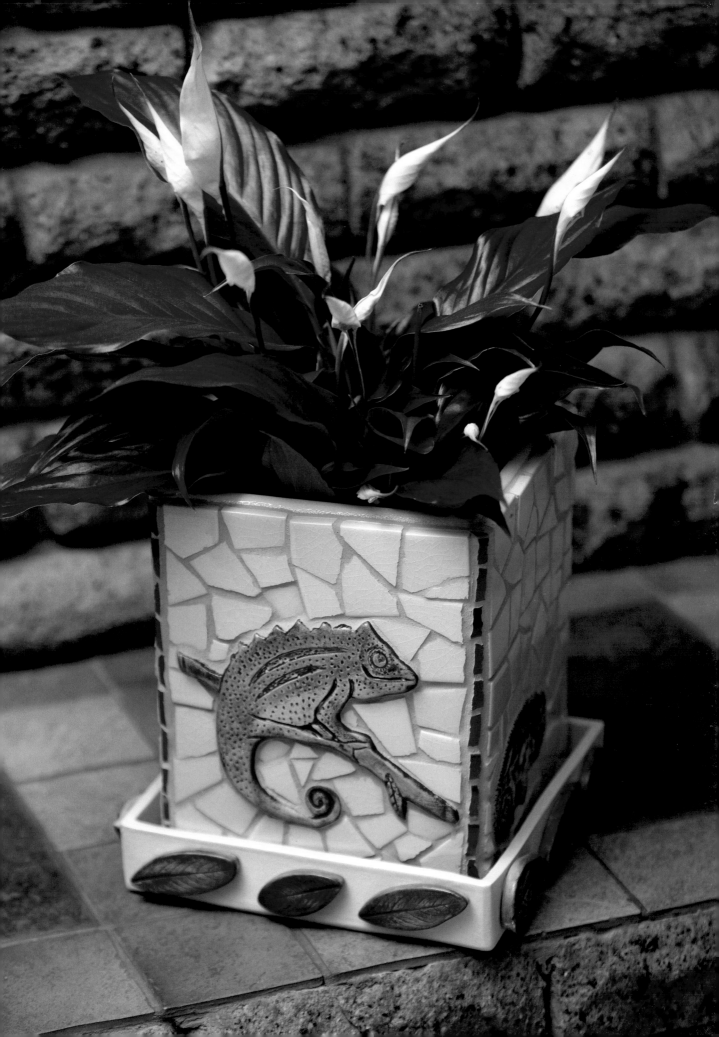

LEAFY ROUND TABLE

■■■

At one stage it was considered the height of décor fashion to own a round, chipboard table, covered in a multitude of cloths. They popped up all over the house and were used as lamp tables or surfaces to artfully display family photographs.

As there is no longer a mad rush for these tables, you will find an abundant supply of them at just about every junk shop. They're dirt cheap and can be modernised with mosaics.

YOU WILL NEED

Wooden chipboard table

Waterproofing sealant

Paintbrush

Cream ceramic tiles with leaf motif

Cream ceramic tiles

Soft pencil

Side biters

Tile adhesive

Palette knife

White grout

Waterproof sealant

Grout applicator

Firm sponge

Lint-free cloth

Plastic strip

Contact adhesive

Oil-based varnish

If the table is going to be outside and exposed to moisture, it's best to paint a coat of waterproofing sealant to the top, side edges and underside of the table top. Leave to dry.

Work out the position of the tiles before beginning to cut by laying a plain tile in the middle and four decorative tiles at each side. Ensure that you leave a little extra space around that middle tile because once you break it and mosaic with it, it will take up more space. Now remove the middle tile and draw pencil lines around the four remaining tiles before removing them.

Use the side biters to break the decorative tiles into irregular pieces and reassemble them (like a jigsaw puzzle) as you glue down the pieces. Use the pencil lines nearest the centre of the table as a guide: you will go slightly over the other three lines because you're making gaps between the tiles. Continue until all four tiles are stuck down.

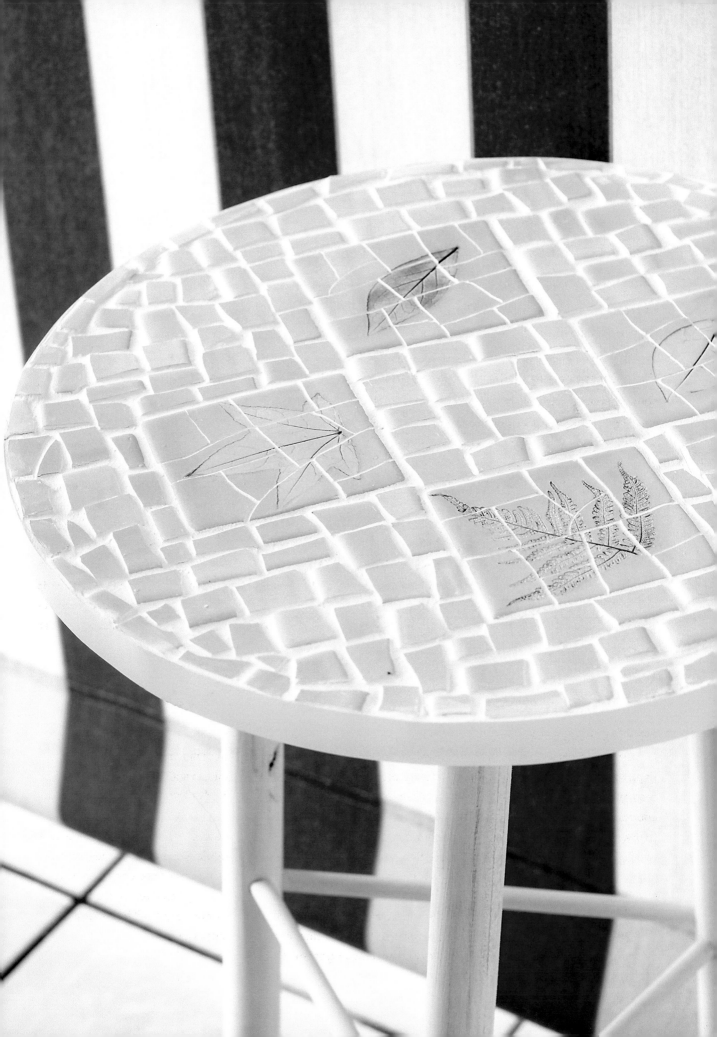

Begin cutting the rest of the plain tiles. Keep them roughly the same size and shape; however you will have to cut smaller pieces to fill in gaps. Start by gluing a border around the edges and then work inwards. When finished, leave overnight to dry.

Mix the tile grout according to the manufacturer's instructions, replacing the water with waterproof sealant, and apply using the applicator. Once you have finished grouting, leave it to dry for about an hour. Then take the sponge, dip it in water and squeeze it until it's almost dry. Wipe it gently over the top and edges of your work in order to smooth the grout and also wipe away the excess from the surface of the tiles. Keep cleaning the sponge as you work but ensure that you squeeze out as much water as possible each time you do so. Leave it overnight to dry and then buff with a lint-free cloth.

Use contact adhesive to glue the plastic strip to the sides of the table top. Seal the rest of the table (including the underside of the top again) with 2 coats of varnish to protect them – allow sufficient drying time between coats.

HANDY HINTS

- We tried to break the tiles but it didn't work as they shattered, probably because they are fairly soft and unglazed. So we ended up using our nippers to cut them.
- We made smaller gaps between the decorative tiles because we didn't want to break up the pattern too much as it is so delicate.
- If you want to give the table legs a bit of a whitewash look, add a little white enamel paint to the varnish. Mix well before applying it.